DISCARD

CHICAGO, ILLINOIS 60625

P9-BAW-756

IMAGES
of America

TAYLOR STREET
CHICAGO'S LITTLE ITALY

JUL - 2

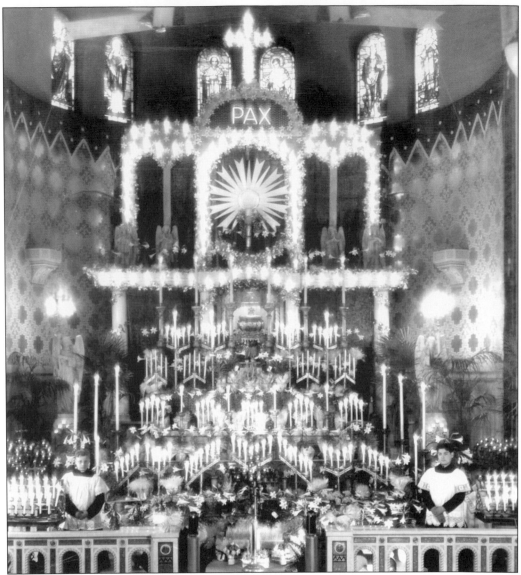

Our Lady of Pompeii Church, a pillar in the Taylor Street community since its inception in 1911, is seen on Holy Thursday 1939. The tradition of Holy Thursday evening includes visiting churches, which stayed open until midnight or later as part of the Easter vigil. The altar is decorated in honor of the Blessed Sacrament. The church continues the Holy Thursday tradition.

On the cover: On July 21, 1942, teenagers jitterbugging in the intersection of Polk and Loomis Streets were showing off a popular dance that began in the 1930s and continued through the 1940s. Jitterbugging was a vigorous dance, once called by newspaper columnist Damon Runyon "a beautiful form of tripping the light fantastic" that required the "pliability of angle worms." The dance was kept popular on Taylor Street by storekeeper Antoinette Castello, who had installed a red, yellow, and orange jukebox outside her store on the corner and sold Italian barbecue and soda while neighborhood teens jitterbugged on the sidewalks from 8:00 p.m. to midnight. Happy parents and wide-eyed children watched. (Courtesy of the Chicago Tribune.)

IMAGES
of America

TAYLOR STREET
CHICAGO'S LITTLE ITALY

Kathy Catrambone and Ellen Shubart

ARCADIA
PUBLISHING

Copyright © 2007 by Kathy Catrambone and Ellen Shubart
ISBN 978-0-7385-5107-4

Published by Arcadia Publishing
Charleston SC, Chicago IL, Portsmouth NH, San Francisco CA

Printed in the United States of America

Library of Congress Catalog Card Number: 2006937463

For all general information contact Arcadia Publishing at:
Telephone 843-853-2070
Fax 843-853-0044
E-mail sales@arcadiapublishing.com
For customer service and orders:
Toll-Free 1-888-313-2665

Visit us on the Internet at www.arcadiapublishing.com

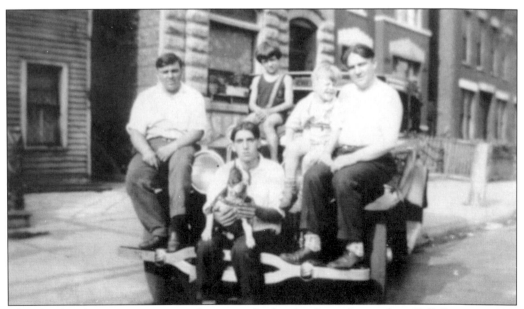

The Blue family creates a portrait piling up on big brother Jimmy's taxi along Polk Street in 1928. The neighborhood streets have always provided an outlet for families to find employment as well as friendship and collegiality. Seen here are, from left to right, Pat Blue and his daughter Rose; brother George with Cheater, the dog; and brother Tony holding his son George. Brothers Frank and Jimmy were not photographed.

R0110040263

CONRAD SULZER REGIONAL LIBRARY
4455 LINCOLN AVE.
CHICAGO, ILLINOIS 60625

DISCARD

CONTENTS

ACKNOWLEDGMENTS

The idea for *Taylor Street: Chicago's Little Italy* evolved because the story of Chicago's Italian Americans often has been focused on tenements, poverty, gangsters, corrupt politicians, urban decay, and Italian dispersion into the suburbs. We wanted to tell the story of the prime Italian American community in the city, including an area often overlooked, the Tri-Taylor neighborhood. The book focuses on the sociology and people of the neighborhood and tells some stories that have never been told. Without the help of many people, this book would never have been born. We gratefully thank Rose Adinolfi, who gave up hours of her time; Mario Angellini, without whose photographs for the Near West Side Slide Archive much of this history would have been undocumented; Joseph B. Catrambone Sr., for his memories and photographs; Marie Davino, whose Pompei bakery has fed generations of Italians and non-Italians alike; Phil DiNatale, who drove from Ingleside to share pictures; Patricia Albano Fitzgerald and Shelia McGuire for their love of St. Callistus; Salvatore Bruno and the *Chicago Tribune* for help and pictures; Dominic Candeloro, who has written so much about Chicago's Italian Americans; Nella Ferrara Davy, who lovingly carries on the family business; Marianne Folise, whose family roots go back to Taylor Street; Mary Fontano, a repository of family history; Donna DiPaolo Jagielski, who shared wonderful memories of her father Mario's lemonade stand; Pat Iannino, a walking history book; Carmella Masi and daughter Barbara, who shared their time and photographs; Louis Monaco and his sister Mary Monaco Del Vale, who safeguard their father's photographs; Richard Policastro and George Randazzo, who quickly answered our call for photographs from the National Italian American Sports Hall of Fame; Camille Provenzano, caretaker of her family's archives; Chris Provenzano, University Village Association executive director, who shared photographs with us; Alba Senese, who willingly participated in our project so that her grandchildren will know their heritage; Peter Senese, a scientist who agreed to ask his mother, Alba, for ancestral photographs; Mary Shimandle, of the Shrine of Our Lady of Pompeii, who opened up the archives; Richard Shubart, who took photographs, read copy, brought in dinner, and myriad other tasks that made the book possible; Darrell Marchioretto, who opened up the files at Casa Italia, Stone Park; and Mark J. Valentino, editor and publisher of the *Gazette*, a font of knowledge who should write his own book. Their contributions have enriched this book. Any mistakes that are found are ours alone.

INTRODUCTION

Since its inception, Chicago has been a city of immigrants, welcoming newcomers. In return, immigrants have made their mark on the city, and none have done so more than Italian Americans. From the plethora of Italian restaurants, the public officials who trace their ancestry to Italian parents or grandparents, and to the Catholic archdiocese, Italian Americans have made a permanent impression on Chicago. The symbol for this history is Taylor Street, Chicago's "Little Italy."

Taylor Street has been on Chicago maps since the city's 1851 annexation of land east of Western Avenue. In the late 19th century, the area now called the Near West Side became known as an Italian neighborhood. Taylor Street itself is the oldest continuously Italian neighborhood in the city. With the influx of Italian immigrants, the Catholic Church opened so-called national churches to serve the Italian population, the Hull House settlement house offered Italian-English classes, an Italian mothers' club, and kindergarten programs, and an eager ethnic workforce sought out manual labor and opportunities to open businesses.

Taylor Street was not the only Italian neighborhood in the beginning, nor is it the only one in the region today. In 2000, more than half a million people in the Chicago region considered themselves Italian, according to the United States census. Italian enclaves were on Grand and Western Avenues, near the Merchandise Mart and the South Side. Italians have dispersed around the city, particularly to Harlem Avenue on the northwest side of the city, and to the suburbs, first to Elmwood Park and Melrose Park, and now to Addison, Carol Stream, Bloomingdale, and beyond. But as Italians moved away from the city center and assimilated, Taylor Street and its sister neighborhood, Tri-Taylor, the original starting points for many, have come to symbolize Italian heritage and culture in Chicago.

By the 20th century, the community's duality became clear—Taylor Street was both the home to Mother Cabrini and her missionaries and hospital and the stamping ground of gangsters in the Italian Mafia, including Frank Nitti. At least one historian dubbed the Taylor Street area in 1968 as one of Chicago's oldest slums—not a ghetto but a street with deteriorating architecture while still harboring a strong feeling of community. Throughout the years, the front stoops remained as places where residents found one another to swap recipes, gossip about children, and just talk. And perhaps even more importantly, this is—and was—the neighborhood where the church resides. Churches here are strong links, second only to family, that created the ties within the Italian experiences.

When urban renewal became the byword of Chicago's government, Taylor Street and its incumbent population were split by development of the University of Illinois at Chicago and

continuing development in the Illinois Medical District. Articles in the city newspapers talked about how Little Italy the old welcomed the new. The new, however, was not quite enough.

It took the 1980s, 1990s, and the new century to bring back a thriving Taylor Street. Residential development along the streets both north and south of Taylor Street was one part of that resurrection. The razing of the public housing projects was another force. The integration of the medical district that bestrides the neighborhood and the university into the neighborhood helped the rebirth. Taylor Street's Italian restaurants have become the draws for tourists and natives alike for their variety of offerings. While Italians ate pasta fazool, polenta, and other dishes every day, today they are restaurant delicacies. Spaghetti and mostacolli in the southern Italian restaurants appeal just as northern Italy's fettucine alfredo does. After myriad changes of immigration, decay, and urban renewal, Taylor Street today deserves its title as Chicago's Little Italy.

The book *Taylor Street: Chicago's Little Italy* focuses mainly on the Taylor Street neighborhood between Halsted Street on the east, Ashland Avenue on the west, Roosevelt Road on the south, and Van Buren Street on the north. Historically the neighborhood has been home to more Italian immigrants and their descendants than any other neighborhood in the city.

Each chapter includes photographs and reminiscences from people whose families have lived and worked on Taylor Street for decades. From the opening chapter about the beginnings, where people are dressed in foreign garb that they brought with them from Italy, to the last in which readers look at the new Taylor Street, the authors have tried to present a snapshot of the life and times of an area and the sociology of the people who have lived there. The book covers family, church, neighborhood, employment, and the disruptions along Taylor Street from the 1880s to the present. The neighborhood farther west has seldom before been included in any discussion or study of Little Italy. This book is an attempt to rectify that by devoting a chapter to the people and institutions of the Tri-Taylor neighborhood, running from Ogden Avenue to Western Avenue, home of St. Callistus Catholic Church.

This book came about because one of the authors, Kathy Catrambone, a well-known local journalist and resident of the neighborhood, was eager to tell its tale, separate from other efforts that have investigated Italian communities in the region but not focused on Taylor Street. Kathy Catrambone grew up along Taylor Street. Her grandfather was the first of four brothers who, with a cousin, settled on a block of row houses near Polk Street on DeKalb (later renamed Bowler) Street. She graduated from St. Callistus School as did her father and many relatives. For more than 80 years, there has been a Catrambone on the block. In 1997, the Illinois Medical District allowed the family to build Catrambone Memorial Family Park on medical district land at Polk and Bowler Streets as a way to honor the family.

Ellen Shubart is an author and journalist who has lived in the Chicago region for her entire life. While not Italian, she was born on Columbus Day (October 12) and has developed both a fondness for Italian cuisine and the history of this important immigrant group in Chicago history. A historian by avocation, she is retired and spends a great deal of her time giving architectural tours for the Chicago Architecture Foundation.

One

IMMIGRANT JOURNEY
NEW COUNTRY, NEW HOME,
AND NEW LIFE

When they first came to Chicago, many Italian immigrants did not think of having come from Italy; a unified Italy did not yet exist. From the first arrivals in the 1850s, when the United States census counted 43 Italians in the city, Italians were *campanilismo*, with an allegiance to a specific village or town. Even after Italy became a country, immigrants closely identified with their villages and tended to settle in neighborhoods with others from the same region. Initially most Italians did not come with the idea of staying.

Until 1880, the Italian community consisted of a few Genoese fruit sellers, restaurateurs, and merchants. Most Chicago Italians trace their ancestry to the wave of unskilled workers who migrated from the south of Italy between 1880 and 1930. Italy traditionally was a country of emigration. During the 1880s, emigration became a mass phenomenon due to the dual economic crises of disease and starvation in Italy itself, improved transatlantic transportation, and the growing demand for labor in North America. Of the five million Italians who came to America before 1965, approximately one quarter were sojourners, who did not settle permanently.

Between 1876 and 1930, 80 percent of the Italian immigrants who arrived in America came from Sicily and southern Italian regions such as Campania, Abruzzo, Molise, and Calabria. Chicago's largest Italian community after 1900 was built around Hull House, the famous settlement house created by Jane Addams and Ellen Gates on Halsted Street. The Italian population that grew up around Taylor Street also included people from Salerno, Basilicata, the Marche, and Lucca. At the opening of the 20th century, what came to be called the Near West Side, or Taylor Street, was an overcrowded area, with tenements and dilapidated houses and a rich density of population.

Often the first stop on an Italian family's journey into Chicago's cultural pluralism, Taylor Street was—and is—home to churches, restaurants, stores, schools, and social clubs that resonate with the Italian language and create a continuing Italian heritage for coming generations. This is that story.

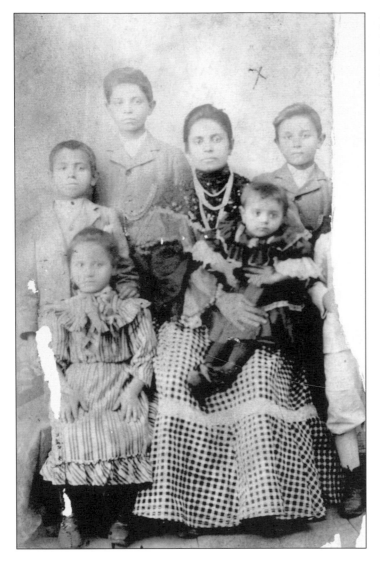

Ready for embarkation to America, Maria Contursi, her five children, and a cousin (not visible) had their photograph taken in Naples.

Agencies such as the Parise Agency of Chicago helped arrange the purchase of tickets for loved ones to rejoin their relatives here. This receipt is for a 1925 ocean liner ticket. (Courtesy of Dominic Candeloro.)

Dressed in traditional early-20th-century baby clothes, Pat Blue was born in 1902 and grew up near Halsted Street. He would start wearing knickers soon and later own his own business in the neighborhood.

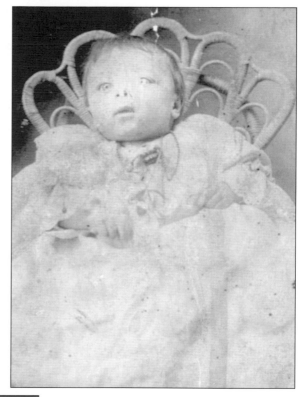

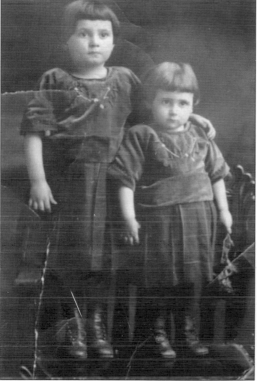

Anita, age seven, and Olga Vallone, age five, pose in matching outfits in a portrait taken in 1926 or 1927. They lived on Bishop Street. Their proud parents made the photograph into a postcard, undoubtedly to send to relatives in Italy.

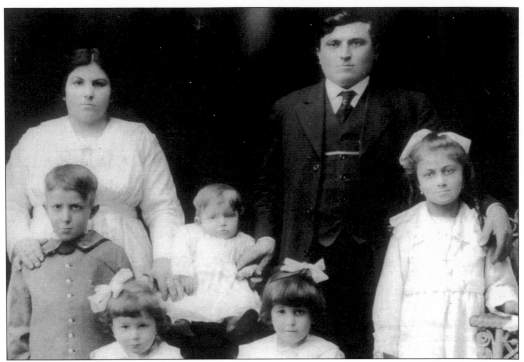

The Scafuri family poses for a portrait in America. Luigi Scafuri was a baker in Italy and initially opened a bakery on Loomis Street. He later moved it to Taylor Street. His daughter Annette runs the bakery as of 2006. Seen here are, from left to right, (first row) Amelia (Millie) and Maria Grace; (second row) Ralph, Annette (baby), and Frances; (third row) Carmela and Luigi. During the Great Depression, Luigi gave out free bread to those who could not afford the 3¢ price.

Frank Soldato and Pauline (Senese) Soldato, who lived on Fillmore Street, pose in a professional photograph taken at Mo Granata Studio, 1551 West Taylor Street, on the corner of Ashland Avenue, with the now old-fashioned telephone number, MOnroe 6026.

Mary and Vito Senese pose with their son Dominic in a c. 1930 portrait. The couple wears American fashion well. Note Mary's marcel, a hairstyle popular at the time.

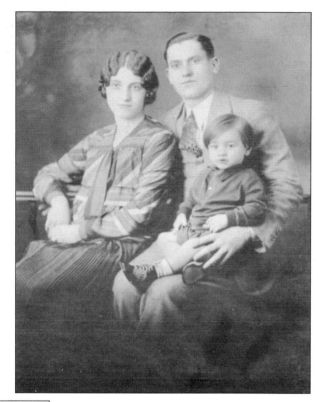

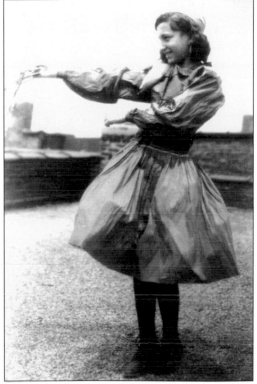

Rita Monaco, age 12, keeps the Italian tradition alive with a dress, a dance, and a tambourine on a rooftop along Lexington Street in 1932.

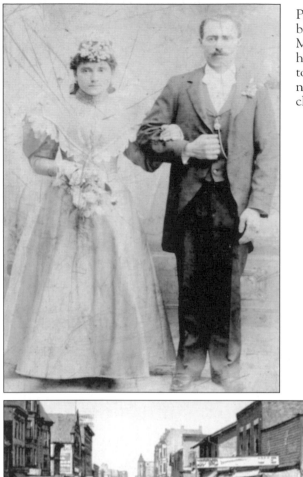

Paolo La Donna and Maria G. Valentine, both from Abruzzi, met and married in Michigan on November 16, 1896. They had three children there before moving to Chicago, settling in the Taylor Street neighborhood, and adding three more children to their family.

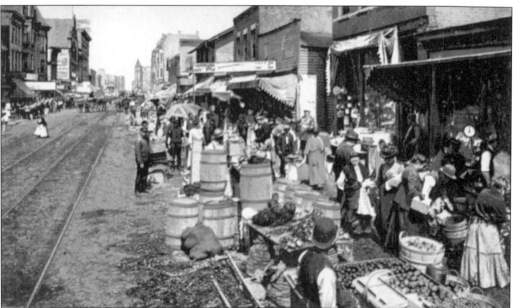

A penny postcard from the Western News Company in Chicago shows the Jefferson Street ghetto where locals bought and sold produce. Many of the early Italian immigrants went into the produce business selecting work with which they were familiar from the old country. This photograph showing brussels sprouts, beets, potatoes, and shoppers likely was taken at the beginning of the 20th century.

Giovanni (John) Danza, known in Italy as D'Anza before his name was changed at Ellis Island, stands in his United States Army uniform in a photograph dated Luglio (July) 1918. Danza secured his United States citizenship by serving in World War I, a practice used by many young male immigrants. Others came to the United States to avoid the required two-year Italian military service. World War I took the lives of 24 Italian American soldiers from Chicago.

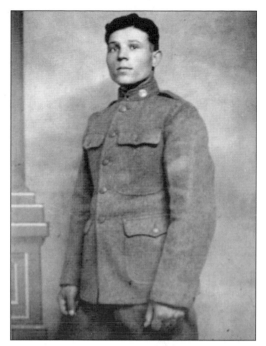

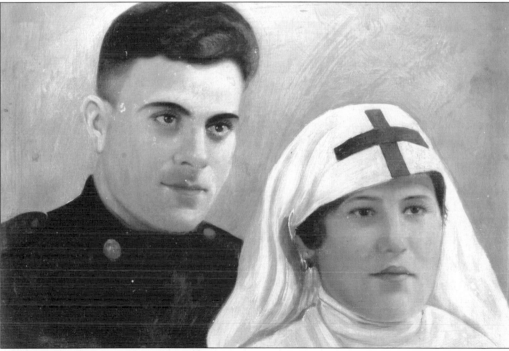

Aniello and Gilda Fontano pose after their marriage. In honor of her husband, who was fighting in World War I, the bride had the artist add a red cross to her veil. After the war, they started a grocery store that evolved into two other businesses at Carpenter and Polk Streets. Their descendants still operate Carm's, a sandwich shop featuring Italian lemonade, and Fontano's, a delicatessen and grocery store across the street. In 2006, Fontano's is a franchise business with six locations and plans for many more in the next 18 months.

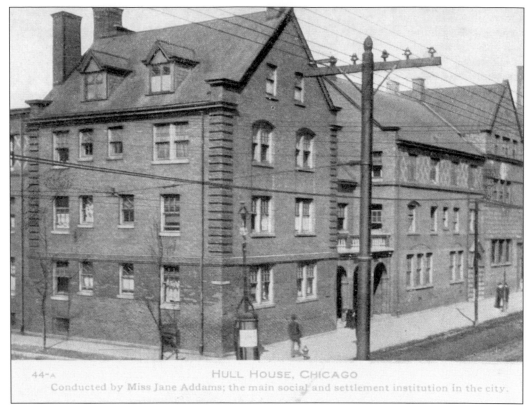

HULL HOUSE, CHICAGO
Conducted by Miss Jane Addams; the main social and settlement institution in the city.

Hull House, shown on a penny postcard, was Chicago's first social settlement, opened in 1889 at 335 Halsted Street, in the middle of the sweatshop district. The card notes that Hull House, "conducted by Miss Jane Addams," was "the main social and settlement institution in the city." Hull House, at one time a complex of 17 buildings, helped Italian immigrants transition into American life through language classes, kindergartens, and voting instruction.

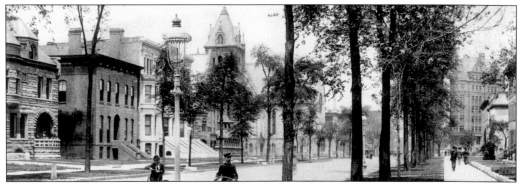

Here is a view of Ashland Avenue looking west, around the beginning of the 20th century. The urban scene was new to Italian immigrants, unused to bicycles and street life. This photograph was taken about one mile away from Hull House. (Courtesy of the Chicago History Museum.)

George Blue (seen in the photograph below), while a minor under 21 years old, having been in the United States for five years and the state of Illinois for one year, and according to his petition for naturalization "having sustained a good moral character," appeared before the Criminal Court of Cook County. In the ceremony on March 14, 1895, he declared his intent to support the Constitution of the United States and renounce all allegiance and fidelity "to every Prince, Potentate, State or Sovereignty whatever, and more particularly all allegiance which he may in anywise owe to the King of Italy."

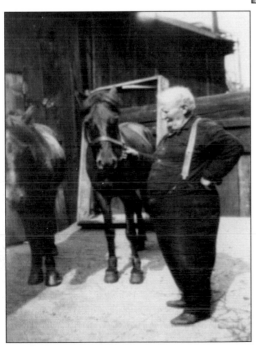

As an adult, Blue peddled fruit and vegetables from a horse-drawn wagon. In the image to the left, he shows off the horse that he kept in a barn behind his home at 1444 West Polk Street.

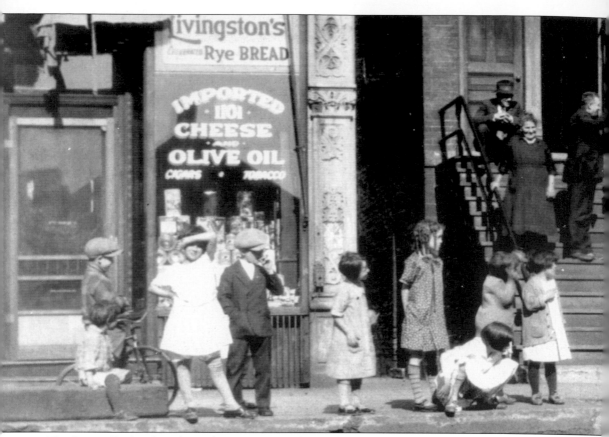

The Puciarello family is shown here in 1926, in front of 1101–1103 South Racine Avenue. Nearby

Giuseppe Catrambone came to the United States in 1904 to build a new life, as did many in the wave of southern Italian immigrants. Catrambone emigrated from Calabria and settled near Hull House. He later would be joined by a number of relatives, when he lived on DeKalb (Bowler) Street.

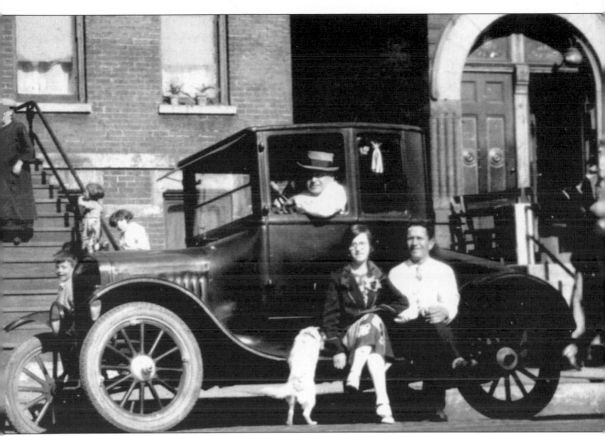

is a shop that sells cheese and imported olive oil. (Courtesy of Dominic Candeloro.)

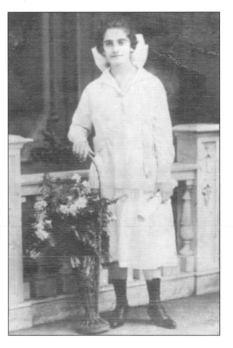

Angelina Provenzano poses with her diploma after her 1918 eighth-grade graduation from Andrew Jackson School, a Chicago public school. In the early 20th century, completing eighth grade was an accomplishment, and few children, especially girls, went on to high school.

A group of boys shows off for the camera, playing in an empty lot in the Taylor Street neighborhood.

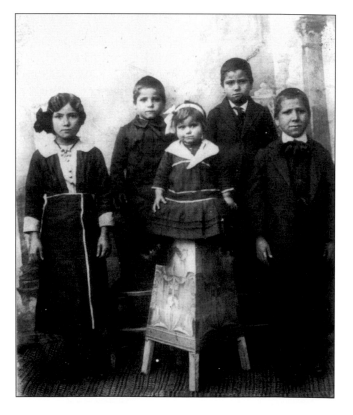

The DiNatale family is, from left to right, Lucy, Sam, Antoinette, Tony, and Carmen. They came from Scordia, Sicily, in 1919. Younger brother Joseph was born later, in Chicago, at their parents Philip and Josephine's home at Taylor and Newberry Streets. Newberry Street, no longer on the map, was three blocks west of Ashland Avenue.

Two

Mama Mia
Family Ties

The two most important institutions to Italian Americans are family and church. Taylor Street denizens affectionately remember close-knit extended family dinners, holiday feasts, and picnics. Extended families included parents, unmarried sons and daughters, and married sons, their wives, and children who lived together, whether at first in one small unit or later—as money became more plentiful—adjoining units. Newly arrived men boarded with families or in rooming houses.

Dinner together was a must. Father's word was law—except where papa needed his children to speak English and interpret American life for him. Early in the 20th century, baths were taken on Saturdays, around the kitchen's coal stove. In the 1920s, men went to City of Chicago bathhouses, while women socialized at home—playing cards, hosting coffee klatches, or listening to the RCA Victrola (record player) playing Italian opera. In the World War II era, those who could afford to own a car would drive up and down Taylor Street and just hang out, if they were not playing baseball. In the summertime, if anyone owned a truck or a horse and wagon, three to four families joined together for a picnic or band concerts in Garfield Park. People with 6¢ took the surface line to Navy Pier for boat rides.

At holiday time, Christmas Eve was the central event. Mothers cooked fish, such as sardines, shrimp, calamari, oysters, and pasta covered with sauces that combined oil, garlic, bread crumbs, and anchovies "to remind you of your humble beginnings." Bingo, often called lotto, followed, and men played cards as everyone watched the candles on the tree, both to protect against fires and to count down to Christmas Day. Stockings were opened, and good children received Italian cookies, candies, and oranges, while those who were bad found a lump of coal. Gifts at first were only for children, until the family had enough money to buy for everyone. Some families waited for presents until Epiphany, recalling the tradition of La Befana, the grandmotherly old lady who carries a broomstick and drops off treats for good children. Many of these traditions continue today.

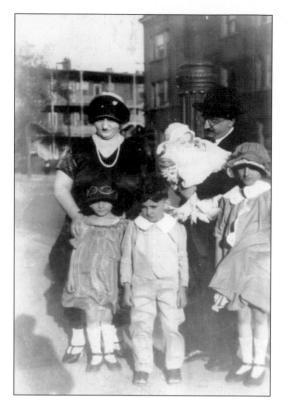

A family outdoors includes Adeline Bellezza and brother-in-law Ernesto Monaco with children in 1925. Dressing well was important, no matter what the budget. Children and parents always dressed up for family affairs and church services.

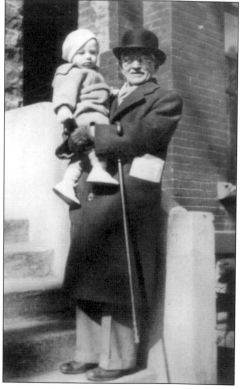

Grandfather Luigi Nigro holds his one-year-old grandson Louis Monaco. Nigro came from Italy at age 12. As an adult, he played violin on a Mississippi River boat and later settled in Chicago, where he owned three apartment buildings on Lexington Street. His many relatives were among his tenants.

Giuseppe Contursi sits for a 1920 portrait with his daughter Immaculata on the day of her wedding at Our Lady of Pompeii Church. The occasions of religious events such as baptisms, weddings, and first communions plus secular events such as birthday parties were family events, kept family ties strong, and strengthened the Italian community's social fabric.

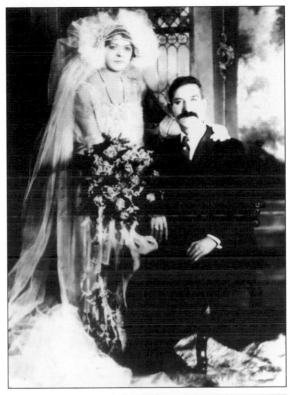

Dr. Giovanni Stranges sits on a bench in front of the building where he lived, 1206 West Lexington Street. His practice was so successful that he was able to take two years off and return to Italy with his family.

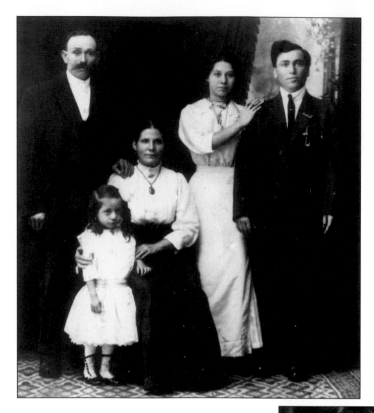

In the parlor in 1914, the Cerabona and Potenza families stand for a multigenerational portrait. Standing in the back is Michael Angelo Cerabona, and seated is his wife, Carmella, with their young daughter Rose. To the right are their married daughter Teresa and her husband, Rocco Potenza.

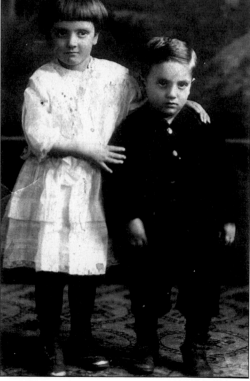

Constance Provenzano hugs her brother Anthony in a 1924 photograph. At the time, this Provenzano family lived at Carpenter and Polk Streets.

In 1912, Carmela Provenzano is surrounded by her children, who are, from left to right, Angelina, Michael (in her lap), and Frances. Large families were the rule among Italians. Provenzano was known in the neighborhood for her healing powers, and children who scraped their knees knew where to go for home remedies and love.

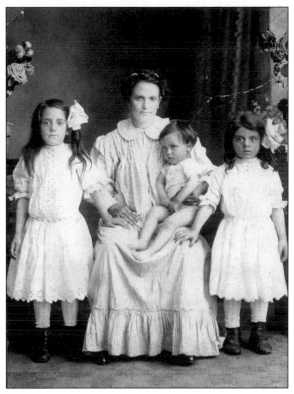

Salvatore and Carmela Provenzano were both not just from Italy but were also from Rende (Cosenza), Calabria. Still, they met and married in Chicago in 1902. This photograph was taken later in life.

Dominic Senese, center, and his relatives Angela Senese (after marriage, Serritella) and Leonard Cotuno stop playing long enough to pose for picture in the front of Dominic's house on Fillmore Street, around 1932. In an earlier time, Fillmore was called Elburn Street.

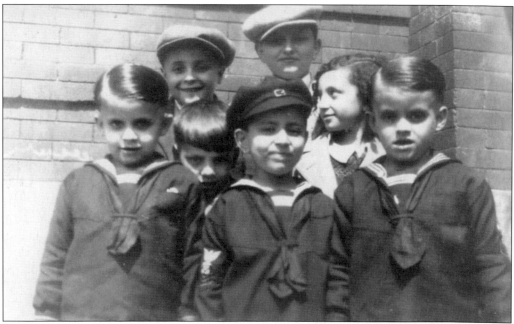

Seven neighborhood children gather on April 14, 1929, to pose for a photograph. Children in the front are wearing sailor suits, popular in that era. Rita Monaco is the sole girl with her brothers and their friends.

On Flournoy Street in the late 1930s, Michael Provenzano, James Folise, and John Danza take a break from playing cards. Michael's daughter, Camille, mugs for the camera. The major means of entertainment for the neighbors came from within themselves; one woman recalled in a 1979 University of Illinois at Chicago (UIC) oral history interview, "We would go from one house to another, with the men playing cards and the women in the kitchen with a coffee klatch."

Immaculata Esposito (seated), her husband Mauro to her left, and their son Andrew to her right take a family portrait at Andrew's c. 1954 wedding. The Espositos' other children are in the photograph.

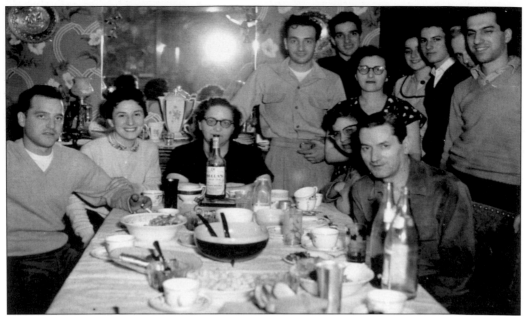

The Senese family of Fillmore Street gathers for a family portrait after a traditional Italian dinner, complete with wine, salad, and pasta. They all lived in a two-flat building at 1452 West Fillmore Street. Visiting was a great event among families, especially if there was an RCA Victrola. Tenor Enrico Caruso and soprano Amelita Galli-Curci were popular, as were the operas *Carmen*, *La Traviata*, and *Il Travatore*, according to one reminiscence.

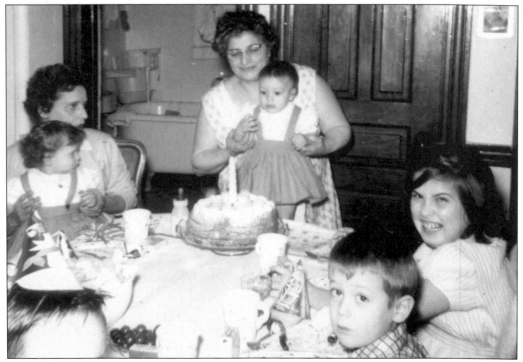

At Gina Adinolfi's first birthday party in 1960, her mother, Rose, helps her blow out the candle at a table with relatives and friends. The home was at Laflin and Polk Streets.

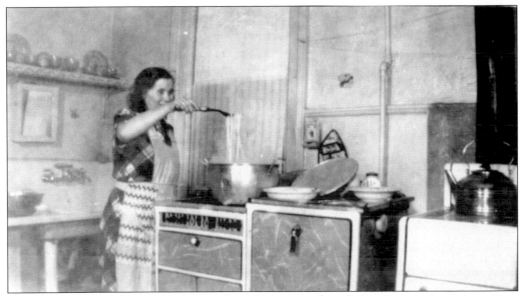

Italian mothers were known for their cooking. Here an unidentified mother spools spaghetti from the pot. (Courtesy of the University of Illinois at Chicago, the University Library Department of Special Collections, Italian American Collection.)

Francesca Esposito, seated in the middle, is surrounded by her eight daughters and two of her three sons in the family home at 625 South Aberdeen Street on Christmas Eve 1946.

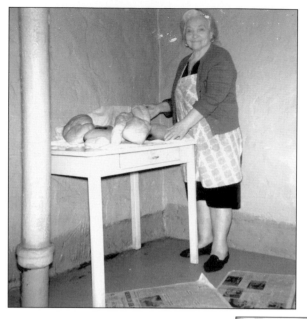

Italians came to the United States with many skills in agriculture and homemaking. In the photograph to the left, a woman, "Mom" Lizzo, cooks in a basement apartment. She baked bread for her family for more than 40 years in a wood-burning oven. In the image below, a man and his children stand in the garden behind their home. Fresh vegetables were a welcome addition to the family table. (Courtesy of Dominic Candeloro.)

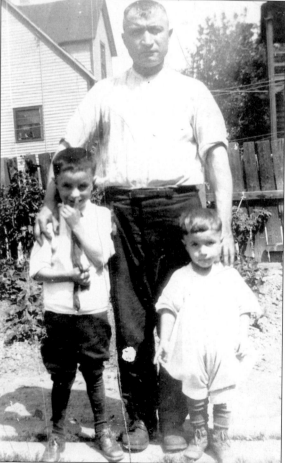

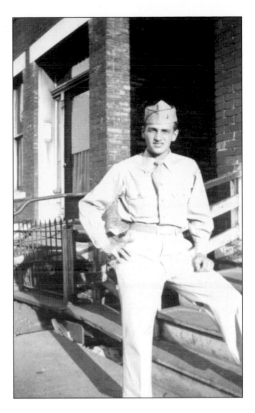

Italian Americans represented the largest ethnic group to fight in World War II. Although Italy was an enemy, most first-generation Italian Americans easily fought for their parents' adopted country. From DeKoven Street alone, 70 boys went off to war. Dominic Senese is on the steps at his Fillmore Street home in the photograph to the right. Joe LoDuca, in the image below, a marine whose picture was taken at Pearl Harbor, lovingly signed the photograph, "Always, Joe." Before the war, he lived at 1006 West Polk Street and sent the picture to a neighbor with whom he corresponded. Both servicemen returned safely.

John Danza and Angelina (Provenzano) Danza pose for a picture in the summer of 1923. The proud couple made the photograph into a postcard to share with their friends and families.

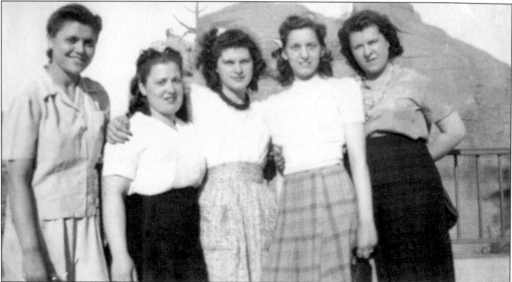

Five friends from the Taylor Street neighborhood and former classmates at McKinley High School are seen here in 1941 on an outing to Brookfield Zoo. They are, from left to right, Theresa Abbamonte, Rose (Molie) Blando, Marion Del Guidice, Carmella Blando, and Felice Del Guidice. The Del Guidices are sisters, while the Blandos are sisters-in-law. Theresa Abbamonte later married into the Del Guidice family.

Three

IN AMERICA
NEIGHBORHOOD AND SCHOOL

Social life revolved around the neighborhood. Populated by *paesani*, emigrants from the same Italian village, these neighborhoods reinforced ethnic identity. Families first moved into rental apartments, holding onto a dream of later buying a home. Two- and three-flat buildings were choice, as they accommodated several generations. Everyone sat on the stoops, especially in hot summers, and everyone knew everyone else by name or appearance.

Following World War I, Taylor Street was the place where Italian bands and clubs thrived, and Italian was spoken on the streets. Residents remember just hanging out at Mario's Snack Shop on Taylor Street near Aberdeen Street. Sheridan Park, with its swimming pool and baseball diamond, was a favorite haunt. The Garden Theater on Taylor Street and Racine Avenue showed Saturday serials.

Italian Americans love secular celebrations. One of the first was the Hull House commemoration of Giuseppe Garibaldi's birthday (born 1807), and another was the 100th anniversary of Italian patriot Giuseppe Mazzini's 1805 birth, an attempt to cement belief in a united Italy. A heroic bust was presented and became "the chief ornament in the front hall of Hull House." Settlement houses were crucial to immigrants; their field trips gave children introductions to museums, the American countryside, and libraries. (Although Jane Addams spelled the settlement Hull-House, the National Register of Historic Places nomenclature of no hyphen is used today.) The Joint Civic Committee of Italian Americans, an organization working for Italian interests since 1952, sponsors the city's annual Columbus Day parade, honoring the discovery of the New World by an Italian hero.

The schools were the most powerful assimilators. Children and adults learned American traditions and English. Included in the curriculum were patriotic songs, the Pledge of Allegiance, and respect for the Declaration of Independence and the United States Constitution. School also equaled "all your friends," said one resident, while high school "equaled the world." In the 1920s, few children went beyond eighth grade. By the 1950s, high school was the norm, and in the 1970s, college attendance was at the national average. The parochial school system also played an important role. Enrollment grew quickly during the first half of the 20th century. Our Lady of Pompeii School, established in 1912 by the Missionary Franciscan Sisters of Immaculate Conception, had 500 children enrolled by 1920.

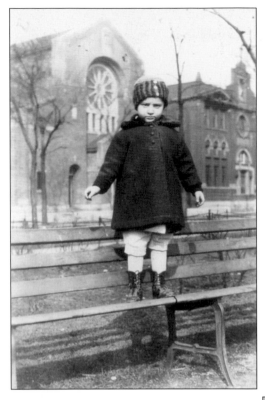

Rita Monaco, age five, stands tall on a bench in the neighborhood park known as Peanut Park, which later would become Arrigo Park. The park was a favorite place for children to play run, sheep, run; buck, buck; and pegs and sticks. Behind her are Our Lady of Pompeii Church and the original Our Lady of Pompeii School. The photograph was taken on March 16, 1925.

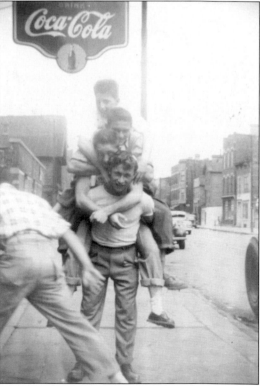

Neighborhood boys enjoy horseplay on Taylor Street in the late 1940s.

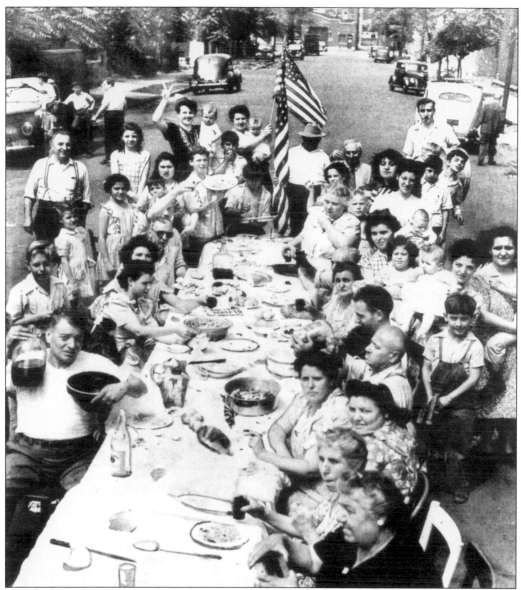

The end of World War II created a spontaneous celebration that moved onto Vernon Park Place and May Street. Neighbors celebrating brought food, homemade wine, smiles, and American flags. Pictured are members of the Russo, DiCara, DeLaurentis, Davino, and DeRosa families, among others. (Courtesy of the Chicago Tribune.)

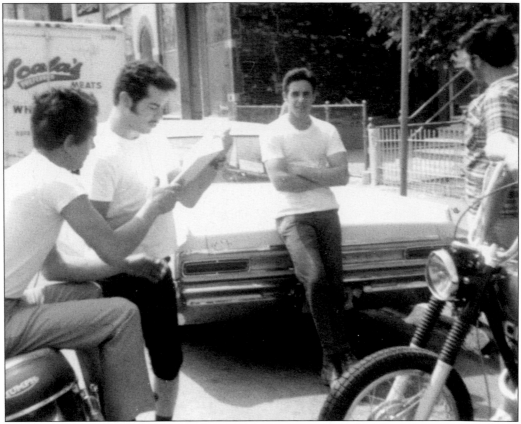

Four teenagers—Ricky Romano, reading, and Gus Mauro, in the plaid shirt, plus two unidentified friends—stand in the 1000 block of Taylor Street in the 1960s. Behind them is a symbol of a popular Chicago business, Scala's Italian Beef. Nate's, a local eatery, was across the street.

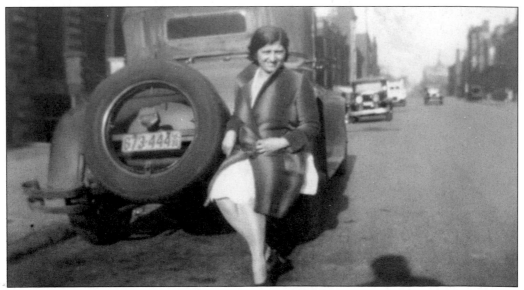

Mildred Blue smiles as she poses on the bumper of a 1930s car parked along Polk Street.

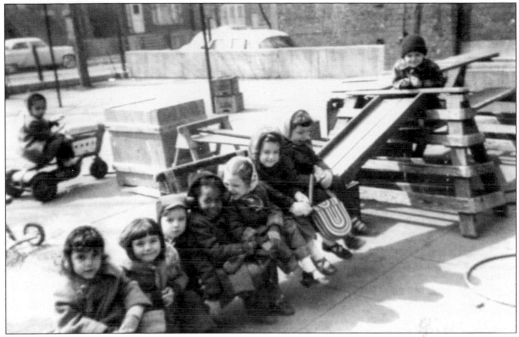

Neighborhood children sit in the Hull House preschool playground in the photograph above. In the image below, the girls in the class play with dolls. As late as 1956, when these photographs were taken, Italian American children were attending Hull House in the footsteps of their ancestors. Hull House was one of the few institutions that combined a policy of Americanization with celebration of the neighborhood's ethnic diversity. As the neighborhood changed, many racial and ethnic groups' families took advantage of the settlement house's services.

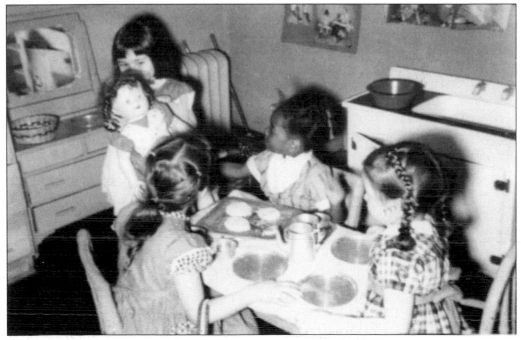

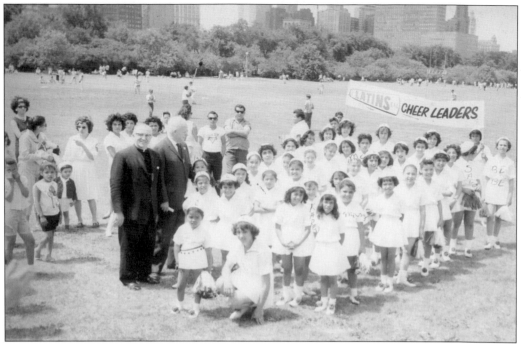

Latin Social Athletic Club cheerleaders, based at Hull House, are in Grant Park for a 1962 citywide baseball tournament. Difficult to identify, Donna DiPaolo is nevertheless among her friends and relatives in the photograph and saved it for more than 40 years.

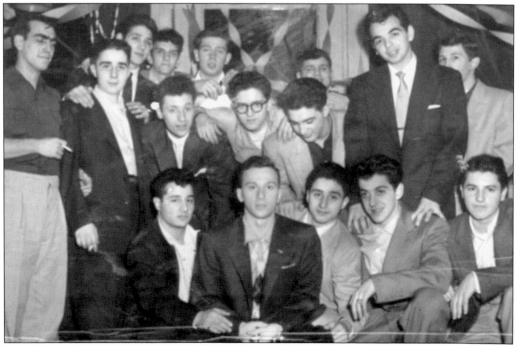

Members of the Enrico Fermi Social Athletic Club pose in 1951 in the building where they met. It was the building owner who instructed the boys to name their club after the famous Italian physicist. The photograph was taken by Phil DiNatale, also a club member.

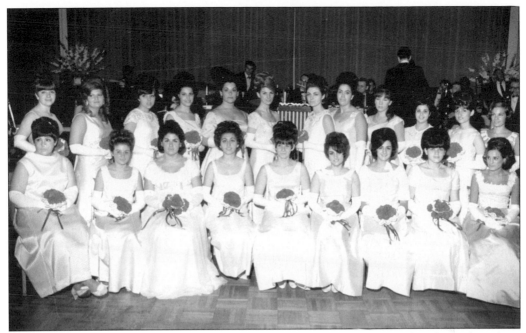

The first Columbus Day Cotillion was sponsored by Our Lady of Pompeii Church as a benefit in 1966. Wearing the traditional debutantes' white, the debutantes were presented by their fathers at the International Ballroom of the Conrad Hilton Hotel. Pictured are the 1967 debutantes. Neighborhood resident Marie Davino was chairman of the Debutante Committee that year, and Bishop Aloysious Wycislo presided at the cotillion.

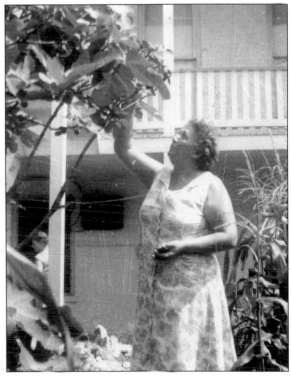

Luigina Iannino picks a fig in 1957 from one of the many fig trees on Bishop Street. To survive Chicago winters, a trench, or *la fossa*, had to be dug around the roots, and the tree had to be folded down into the trench, buried and covered with heavy materials. Luigina's husband, Pasquale, did this up to the age of 80.

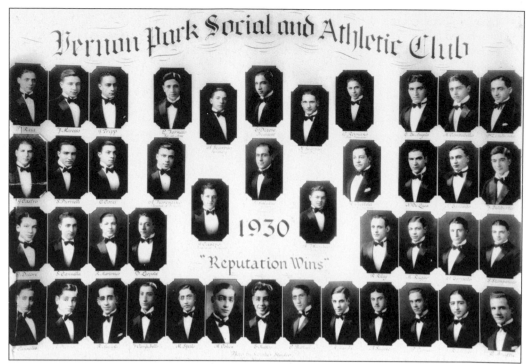

Men of the neighborhood organized the Vernon Park Social and Athletic Club as a way to form friendships, have fun, and do good works. The motto was Reputation Wins. Pictured here is the 1930 membership.

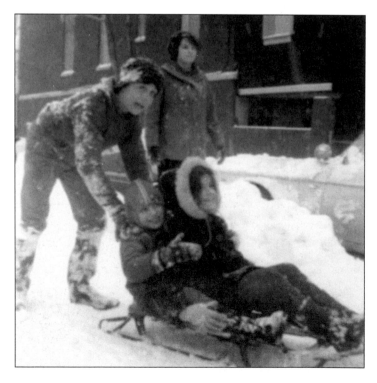

The blizzard of 1967 created havoc with traffic but also made for great sledding along Carpenter Street that January.

Two Dominic Seneses around 1950 laugh and joke about the "which Dominic is which?" confusion they often caused. The two cousins, who were also friends, lived in the same building in apartments on top of one another. In the tightly knit Italian community, having family in the same building was common as was—and is—having cousins as best friends. To this day, they are known as Dominic Upstairs, left, and Dominic Downstairs and are still best friends.

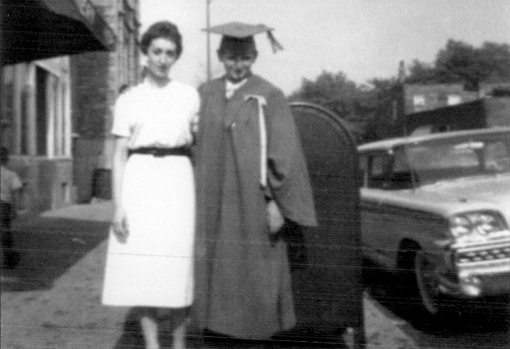

Rose Adinolfi and Billy Taglia, a neighborhood child whom Adinolfi looked upon as a son, are seen here standing in front of her family business, Rosann's Bakery, to celebrate his 1959 graduation.

In the image at left, Marcello (Marc) Monaco, age eight, enjoys reading the 1925 newspaper comics at his house on Lexington Street. In the image below, brother Roland Monaco, age four, takes his bicycle in 1931 to Peanut Park (later Arrigo Park). In the background are Lexington Street homes, still standing in 2006.

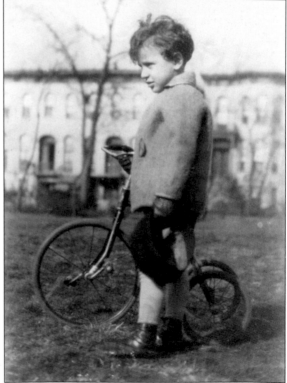

The Knights of Capri began in 1954; the image above, dated around 1958, was taken at the home of Anthony Frelo on the 1100 block of Taylor Street with 18 of the approximately 50 members. The Knights of Capri was a social athletic club from Taylor and May Streets known for its excellent baseball team. Social athletic clubs were popular throughout the neighborhood, including the BeeTees from Loomis and Taylor Streets, the Bishops from Taylor and Bishop Streets, and the Racine Club from Racine Avenue and Lexington Street. Besides playing sports, the clubs sponsored dances and parties. Members of the Knights of Capri in the 1970s can be seen in the image below, at the wedding of member Robert Mazzone's daughter.

In the image at left, at 1006 West Polk Street, Carmella and Mary Blando, sisters, are in the upper window, and Johnny and Virginia Blando are out front. The Blandos lived above their aunt's grocery story until father Dominic Blando turned the property into the Pool Room in 1940.

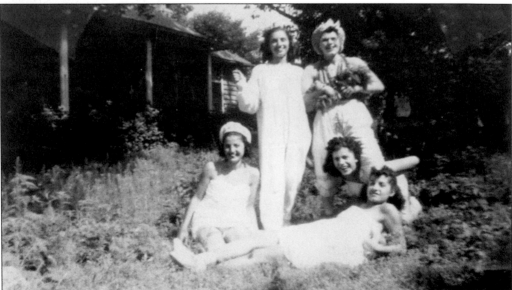

Children of the neighborhood often went to Bowen Country Club, a facility of Hull House, in Wisconsin. Here the members of the Little Women's Club, from left to right, Carmella Blando, Marion Del Guidice and Christine Nichilo (standing), Marge Terraciano, and Lena Nichilo are shown in 1940.

Neighborhood boys flocked to meet middleweight boxing champion Rocky Graziano, who came to visit 923 South Bishop Street in 1947. The two proud boys on each side of the smiling fighter are Chuck (left) and Louis Giampa.

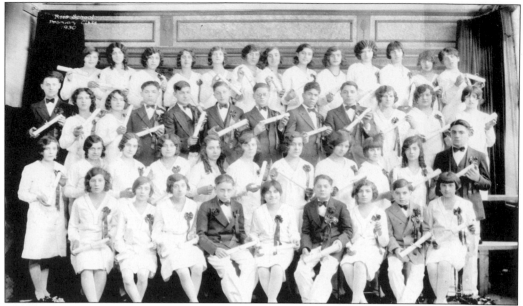

Jacob Riis School at Fillmore and Throop Streets is now closed but at one time was the major public school for the neighborhood. Named after famous reformer and advocate for the poor and working man, Riis graduated many students, including this primarily Italian class from 1930. (Courtesy of Dominic Candeloro.)

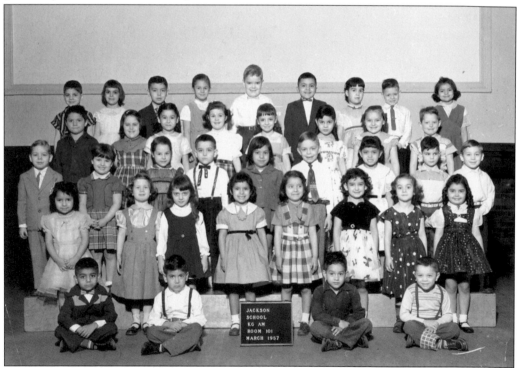

The morning kindergarten class of Jackson School had this photograph taken in March 1957. Today Jackson Academy is at 1340 West Harrison Street, while the former location is now home to Galileo Scholastic Academy at 820 South Carpenter Street.

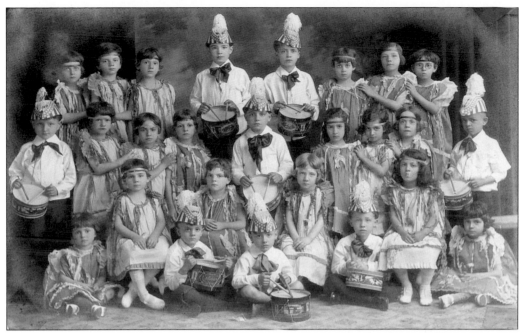

For a school event, likely in the late 1920s and in time for Columbus Day, children of Italian American immigrants at Our Lady of Pompeii School create a tableau, decked out in American hats and Native American outfits. Schools were the conduits for learning about American traditions and holidays.

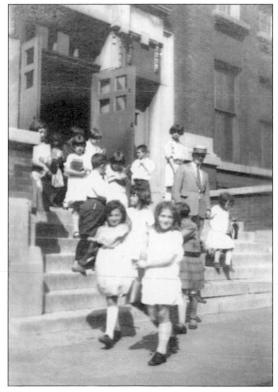

Schoolchildren exuberantly run out of the original Our Lady of Pompeii School, 1220 West Lexington Street, on a sunny September 13, 1928, with one father in a straw hat who came to pick up his child. The girl at front left is Rita Monaco, age nine, who attended the school, which was down the street from her house.

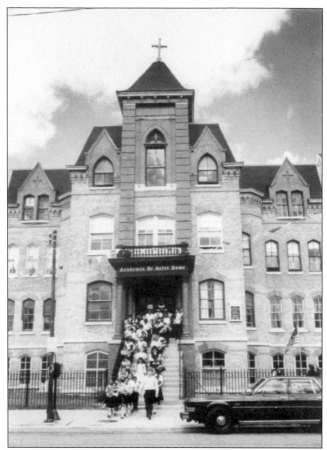

Construction began on the Notre Dame de Chicago Academy in 1887. Irish Catholics often joined their French-speaking neighbors in worshipping at Notre Dame at the latter part of the 19th century; Italian immigrants became parishioners during the 1920s and after. The image to the left shows the school and students in the 1960s. In 1988, due to lagging enrollment and high building repair cost estimates, Notre Dame closed its school doors. The picture below, taken on May 26, 1992, shows the demolition. As of 2006, Notre Dame parish operates Children of Peace School for preschoolers through eighth graders at Wolcott and Taylor Streets. (Courtesy of the Gazette.)

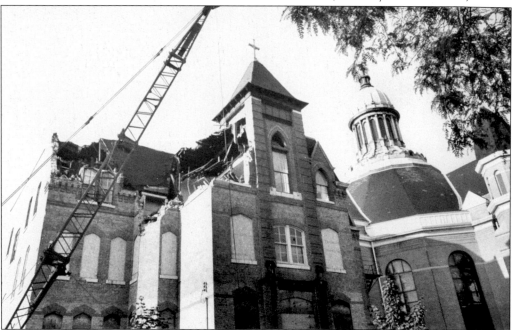

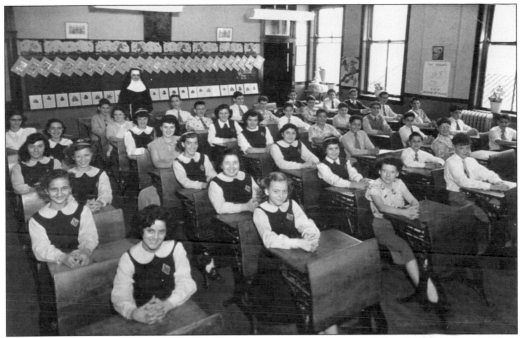

This is an early 1960s classroom photograph at Our Lady of Pompeii School, with a few children who were probably in trouble because they did not wear their uniforms that day. The nun-teacher is wearing a full habit, a Catholic Church tradition that was modified and later abandoned following the Second Vatican Council.

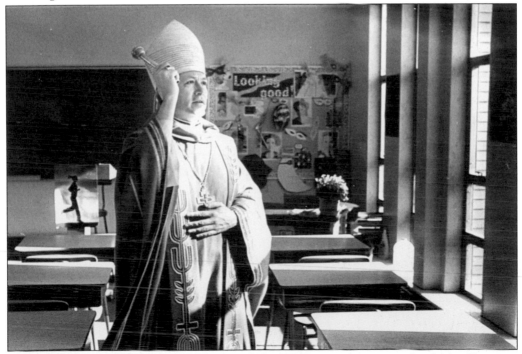

Bishop Placido Rodriguez of the Archdiocese of Chicago blesses a classroom at Our Lady of Pompeii, prior to the school welcoming former Notre Dame school students. (Courtesy of the Gazette.)

A nun poses with two graduates from St. Mary High School, which was located on Taylor Street until it was razed in the 1970s.

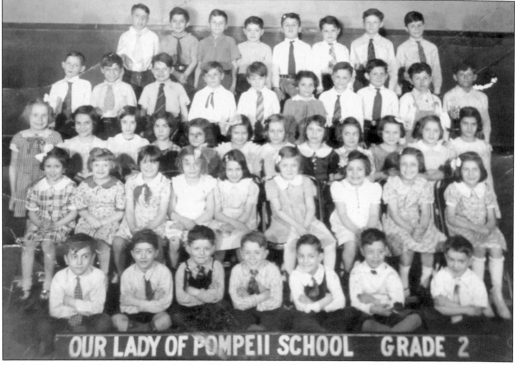

OUR LADY OF POMPEII SCHOOL GRADE 2

In this image, grade two of Our Lady of Pompeii School, probably in 1946, smiles for the camera. The teachers who began teaching in the school when it was opened in 1912 were of the order of the Missionary Franciscan Sisters of Immaculate Conception.

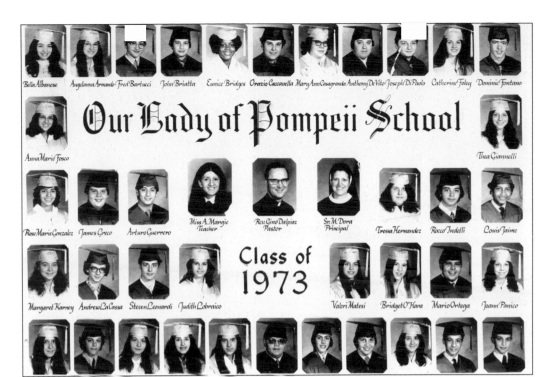

Our Lady of Pompeii School

Bella Albanese · Angelanna Armando · Fred Bartucci · John Briatta · Eunice Bridges · Orazio Caccavella · Mary Ann Casagranda · Anthony DeVito · Joseph DiPaolo · Catherine Foley · Dominic Fontano

Anna Marie Fosco

Thea Giannelli

Rose Marie Gonzalez · James Greco · Arturo Guerrero · Miss A. Margie Teacher · Rev. Gino Dalpiaz Pastor · Sr. M. Dora Principal · Tressa Hernandez · Rocco Indelli · Louis Jaime

Class of 1973

Margaret Karney · Andrew LaCassa · Steven Leonardi · Judith Lobraico · Valeri Matesi · Bridget O'Hara · Mario Ortega · Joann Panico

The class of 1973 from Our Lady of Pompeii School smiles in its graduation garb. Italians were the majority ethnic group in the school, but other Catholics also sent their children there.

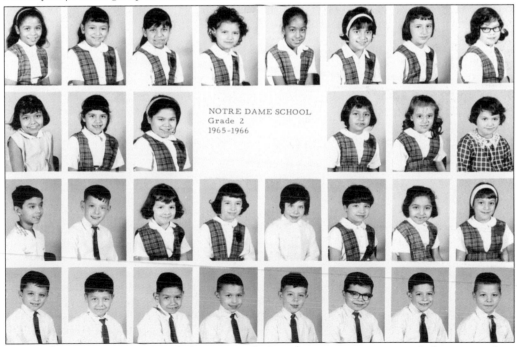

NOTRE DAME SCHOOL
Grade 2
1965-1966

Although the church was founded as a French Canadian institution, many Italians sent their children to Notre Dame de Chicago parochial school. This is the second grade in 1965–1966. The school was razed in 1992.

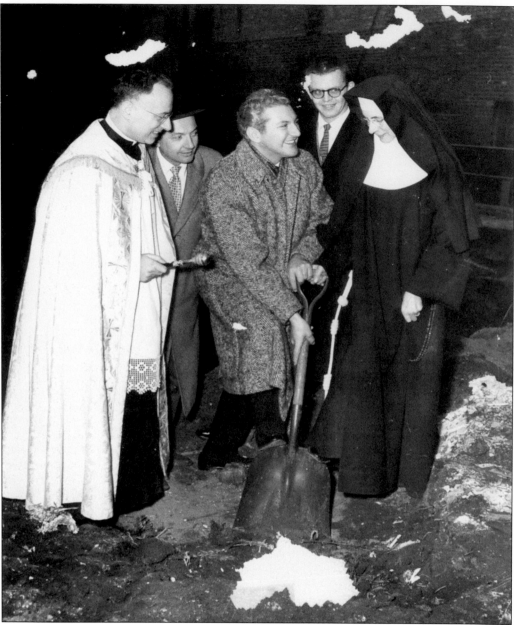

Wladziu (Walter) Valentino Liberace (1919–1987), better known simply as Liberace and to his friends as Lee, was a charismatic and flamboyant entertainer who grew up in a musical family of Polish Italian heritage. His television series debuted in 1952. For decades, Liberace was known for his music, candelabra, charisma, rhinestones, and dazzle. In the late 1940s, before he made it big, Liberace played in small clubs in Chicago, including Melody Garden in the garage behind Carbone's Barber Shop at Loomis and Grenshaw Streets. Edith "Kitty" Pastore, an early fan, worked as a supporter and quasi-agent for the fledgling artist. Liberace returned to the neighborhood as a guest and joined the Reverend Joseph Bolzan and nuns at the Our Lady of Pompeii School when they broke ground in 1951 for a new convent for the teaching sisters.

Four

PRAY FOR US
THE IMPORTANCE OF THE CHURCH

If the family was first in life, the church was a close second. Italians sought out the church for worship and social life. Immigrant groups fostered their own language and their own brand of Catholicism. Most of Chicago's early Catholic churches were German or Irish and did not understand the Italians' highly personal, saint-oriented folk religion. Until the Archdiocese of Chicago's establishment of national parishes, Italians felt unwelcome.

Chicago's first Italian church was Church of the Assumption, on 323 West Illinois Street, and founded by Genoese in 1886. By 1929, there were 11 other Italian Catholic churches in the city, most promoted by Archbishop James Quigley, who, despite his Irish background, understood Italians' needs. Our Lady of Pompeii, on 1224 West Lexington Street, was organized in 1911, built to relieve overcrowding at the older (1899) Holy Guardian Angel, on 178 Forquer (now Arthington) Street. Our Lady of Pompeii soon eclipsed its mother church. The present 1923 building is adorned with images of the Virgin Mary and stained-glass windows from Austria. In 1994, the church became a shrine. St. Callistus, on 2167 West Bowler Street, was founded in 1919. Until 1992, the Scalabrini Fathers supervised the Italian churches in accord with their mission to care for immigrants. In the mid-1990s, St. Callistus became part of Notre Dame de Chicago, a French-Canadian church at 1334 West Flournoy Street.

Italian parishes were active. Our Lady of Pompeii sponsored athletic teams supported by local politicians or taverns and a summer camp in Holly Hill, Wisconsin, 100 miles from Chicago, conducted English classes, and advised immigrants. *Feste*, or festivals, expressing Italian Catholicism's unique traditions, began in Chicago in 1890. Celebrations of saints' days became neighborhood and family events, featuring food and music. Parishioners pulled or carried statues of the saints through the neighborhood. Money was pinned to the statue as a sign of devotion or as thanks for favors. Bands, schoolchildren, and societies with banners followed. St. Joseph's Table celebrations, held in private homes until the 1950s, became popular enough that St. Callistus Church held the first public celebration in 1954.

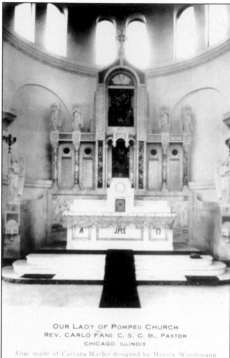

OUR LADY OF POMPEII CHURCH
REV. CARLO FANI, C. S. C. B., PASTOR
CHICAGO, ILLINOIS

Altar made of Carrara Marble designed by Messrs. Worthmann and Steinbach, Chicago, and produced in the studios of DAPRATO STATUARY COMPANY, Chicago, New York, Pietrasanta, Italy.

Our Lady of Pompeii Church, first led in 1911 by the Reverend Peter Barabino, was built because Holy Guardian Angel Church was overcrowded. This postcard was taken in 1919 when the Reverend Carlo Fani, a Scalabrinian Father, was pastor. The altar is made of Carrara marble, designed by Worthmann and Steinbach and produced in the studios of Daprato Statuary Company, both of Chicago. The latter is still in business today.

The Taylor Street neighborhood, shown right, housed 3 of the first 12 Italian churches in Chicago. The first was Holy Guardian Angel, established in 1899 at 178 Forquer (now Arthington) Street; the second was Our Lady of Pompeii, established in 1910–1911 at 1224 Macalister Place (now Lexington Street); and the third was San Callisto (St. Callistus), established in 1919 at 2167 West DeKalb (now Bowler) Street. (Courtesy of Dominic Candeloro.)

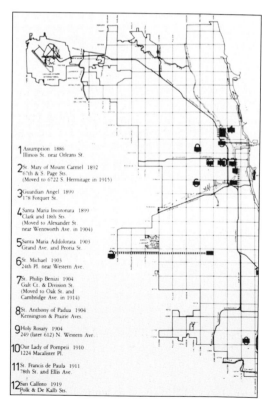

1 Assumption 1886
Illinois St. near Orleans St.

2 St. Mary of Mount Carmel 1892
67th & S. Page Sts.
(Moved to 6722 S. Hermitage in 1915)

3 Guardian Angel 1899
178 Forquer St.

4 Santa Maria Incoronata 1899
Clark and 18th Sts.
(Moved to Alexander St.
near Wentworth Ave. in 1904)

5 Santa Maria Addolorata 1903
Grand Ave. and Peoria St.

6 St. Michael 1903
24th Pl. near Western Ave.

7 St. Philip Benizi 1904
Galt Ct. & Division St.
(Moved to Oak St. and
Cambridge Ave. in 1914)

8 St. Anthony of Padua 1904
Kensington & Prairie Aves.

9 Holy Rosary 1904
249 (later 612) N. Western Ave.

10 Our Lady of Pompeii 1910
1224 Macalister Pl.

11 St. Francis de Paula 1911
78th St. and Ellis Ave.

12 San Callisto 1919
Polk & De Kalb Sts.

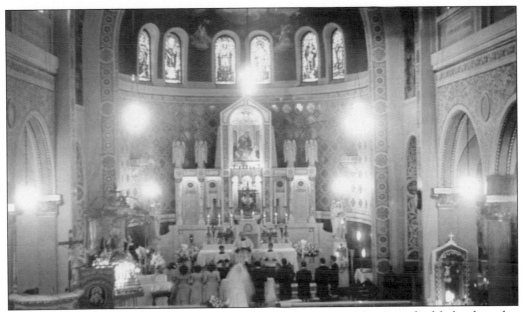

The interior of Our Lady of Pompeii, at 1224 West Lexington Street, is highlighted in this photograph of a wedding ceremony in the 1940s. It is filled with Marian images, particularly *Our Lady of Pompeii—Queen of the Rosary*. The portrait of Our Lady of Pompeii illustrates the rosary as Mary's gift to the Catholic Church.

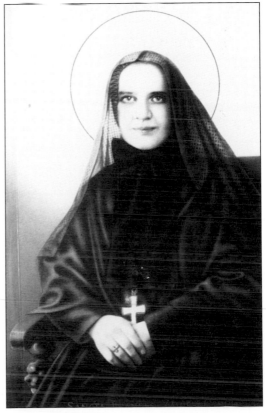

St. Frances Xavier Cabrini (called Mother Cabrini), the first American citizen to become a Catholic saint, was born in Italy. She and her companions formed the Missionary Sisters of the Sacred Heart in November 1880, whose mission included, among other goals, to maintain orphanages and hospitals and perform social work overseas. The Cabrini Hospital was near Our Lady of Pompeii Church. Her work with Italian immigrants ended with her death in Chicago on December 22, 1917. (Courtesy of Dominic Candeloro.)

The Missionary Sisters of the Sacred Heart came to Chicago in 1899 at the request of Archbishop James Quigley. Mother Cabrini established Columbus Hospital in that year on the north side of the city and the Columbus Extension Hospital, or Cabrini Hospital, in the Taylor Street neighborhood. This is the Cabrini Rectory. (Courtesy of Near West Side Slide Archive.)

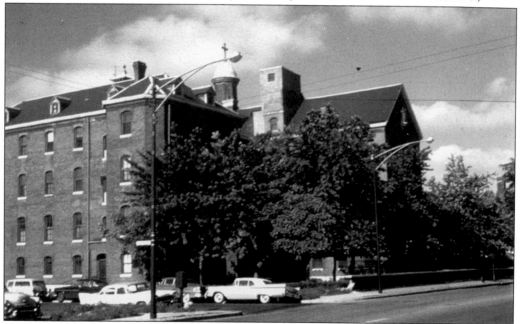

Jeanne Jugan was the founder of the order of the Little Sisters of the Poor. She was beatified in 1982. Working with the sick and the poor, the order was active in Chicago as well as myriad other American cities after sisters came from the home of the order, France. This is the location of the Little Sisters of the Poor in the Taylor Street area. (Courtesy of Near West Side Slide Archive.)

The Madonna Center, at 718 South Loomis Street, was a Catholic settlement house. It served Italian immigrants from 1910 through approximately 1970 and was one of the first social service agencies in Chicago. Under the leadership of Mary Agnes Amberg, the Madonna Center sponsored a variety of programs, including St. Ann's Day Nursery, a medical clinic, Boy and Girl Scout troops, arts classes, sports, and summer programs. (Courtesy of Near West Side Slide Archive.)

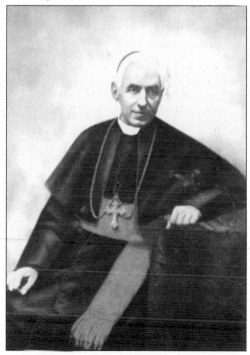

Bishop John Baptist Scalabrini, founder in 1887 of the Missionaries of St. Charles/Scalabrinians. The Scalabrinians supervised Holy Guardian Angel, Our Lady of Pompeii, and St. Callistus parishes. In 1901, Bishop Scalabrini visited America to plan for the care of arriving immigrants. While in Washington, D.C., he met with Pres. Theodore Roosevelt to protest inhumane treatment at Ellis Island. Bishop Scalabrini was beatified on November 9, 1997, by Pope John Paul II.

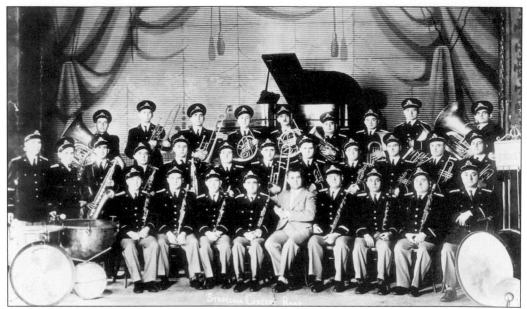

The Strocchia band, led by maestro Raffaele Strocchia, was the leading Italian band in Chicago from 1926 until the maestro's death in 1968. The band, which practiced in the garage of Strocchia's house on Lexington Street near Our Lady of Pompeii Church, performed classic Italian band compositions from the 1890s to 1950s at religious and street festivals throughout the Midwest. The band also played operatic music, often accompanied by lyric opera singers, bringing music to immigrants who could not afford concert or opera tickets. The band performed at major events such as aviator Gen. Italo Balbo's landing in Chicago at the Century of Progress World's Fair of 1933.

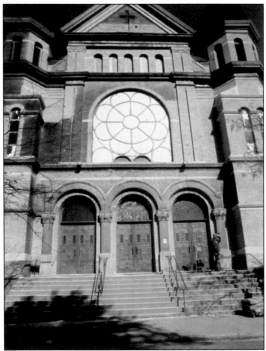

Notre Dame de Chicago was built in honor of Mary, at 1334 West Flournoy Street. The Romanesque Revival structure, built between 1887 and 1892, was designed by French architect Gregory Vigeant. Inside are 16-by-26-foot glass windows crafted by Laschelles and Schroeder in Victorian shades of brown, blue, and violet. (Courtesy of the Gazette.)

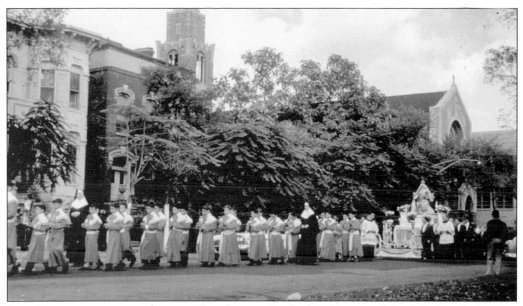

Seen here is a procession of nuns and students at Our Lady of Pompeii School. Italian Americans brought the tradition of processions and parades with them when they came to the United States. In religious processions, the statue of a saint or the Blessed Virgin is carried on a platform by men through the streets of the community. (Courtesy of the University Village Association.)

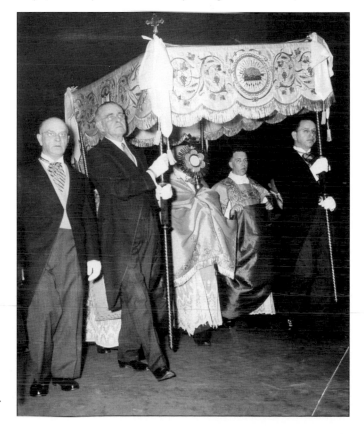

This is a procession of the Notre Dame de Chicago Catholic Church Nocturnal Adoration Society, carrying the Blessed Sacrament. The men's group met on the first Saturday of every month, 1920s–1960s. Women were not permitted to participate or sit in the church's main section when the society held its mass. However, the women would cook a dinner held in the social hall following the mass. This photograph is from the 1940s. (Courtesy of the Gazette.)

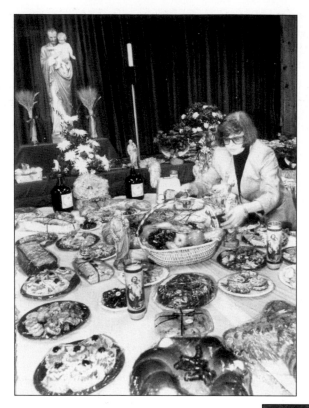

Seen here is a St. Joseph's Table celebration at Our Lady of Pompeii Church on March 15, 1992. Table chairperson Francesca Cesario places a fruit basket near traditional Italian pastries and bread. St. Joseph's Table honors St. Joseph, the patron saint of workers. Traditionally St. Joseph's Tables were held to feed the poor. While some say the tradition is solely Sicilian, others point to other places in Italy that held similar events. (Courtesy of the Gazette.)

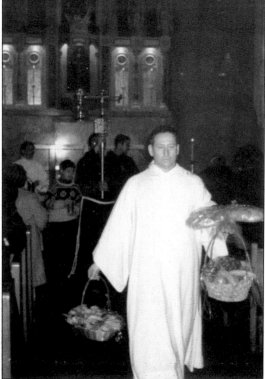

At Our Lady of Pompeii, food is blessed during mass before the St. Joseph's Table begins. In this 2001 picture, food baskets are brought to the Table. On some St. Joseph's Tables, 12 types of fish represent the apostles, set in three tiers symbolizing the Trinity, or holy family.

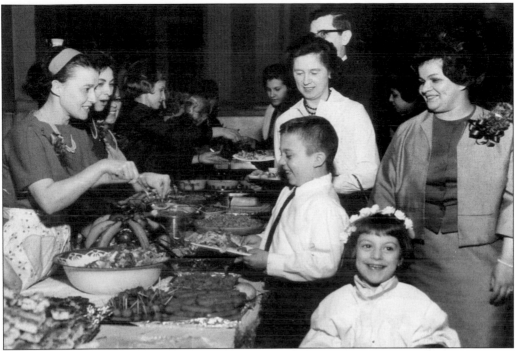

Visitors delight in being served at the St. Joseph's Table at Notre Dame de Chicago Church on March 19, 1964. In front, a young woman is dressed as an angel, which was a tradition. In many events, bread is baked in the shape of St. Joseph's staff, the cross, and Mary's immaculate heart.

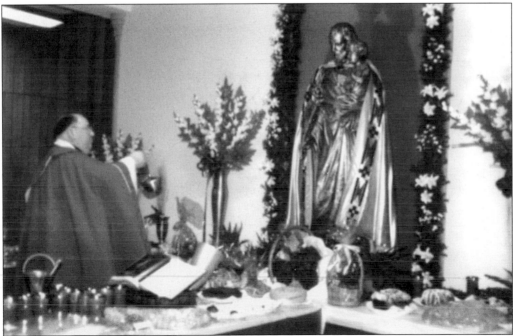

The blessing of the St. Joseph's Table by the parish priest is a tradition at all churches that hold St. Joseph's Tables. The photograph, from Notre Dame de Chicago, shows the statue of St. Joseph and baby Jesus.

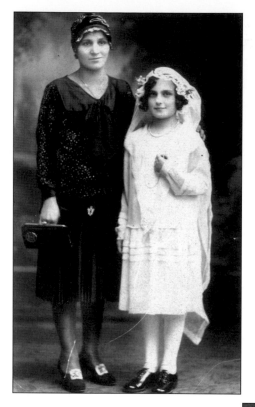

Francesca (Contursi) Esposito was a sponsor in the 1925 confirmation at Our Lady of Pompeii Church.

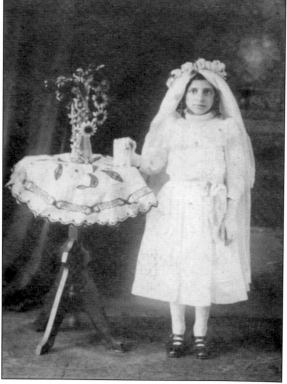

Mildred LaDonna makes her first Holy Communion at Holy Guardian Angel Church around 1910.

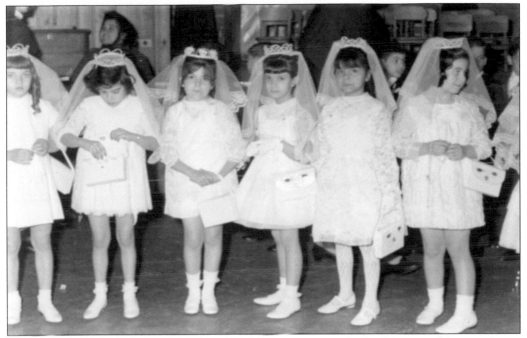

A group of girls around 1969, including Mary Fontano, get ready for the communion service at Our Lady of Pompeii Church. The photograph was taken by Linda's Studio, Photographs for All Social Events, located at 2479 West Polk Street.

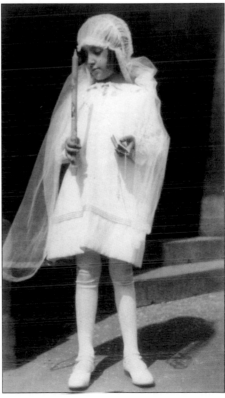

Rita Monaco, age eight, is at her first Holy Communion, on the steps of Our Lady of Pompeii Church, on May 5, 1928.

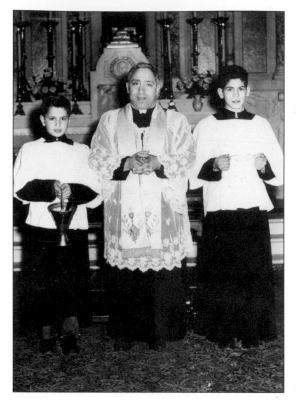

Altar boys Roger (left) and Robert Davino pose with the Reverend Anthony Carrano at Our Lady of Pompeii before a service. The photograph is from the 1950s.

Lorado Monaco strikes a pious pose on the steps of the original Our Lady of Pompeii School on April 7, 1934.

Marcello Monaco poses for his first communion in 1924, at Our Lady of Pompeii Church. His faith remained strong as he became a priest in the Archdiocese of Chicago and returned to Our Lady of Pompeii to celebrate his first mass in May 1942, below.

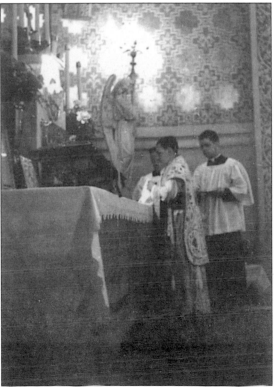

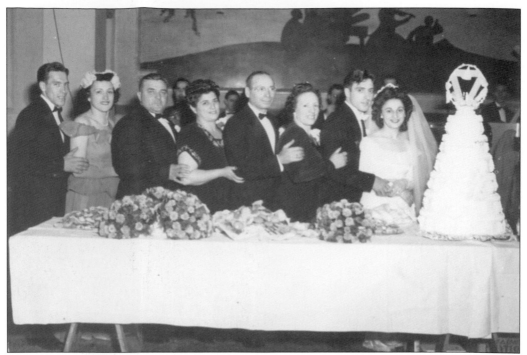

Standing happily behind the cake in the image above is the wedding party of Rose Blue and Frank Adinolfi, who were married in 1946. Mass was held at Our Lady of Pompeii Church. Seen are, from left to right, Jim Adinolfi and Antoinette Adinolfi Gioia, the groom's brother and sister; Pat and Mildred Blue, the bride's parents; Jim and Concetta Adinolfi, the groom's parents; and the happy couple, Frank and Rose. In the image below, the bride and groom leave the church in a hail of rice—the groom smiling but the bride ducking away.

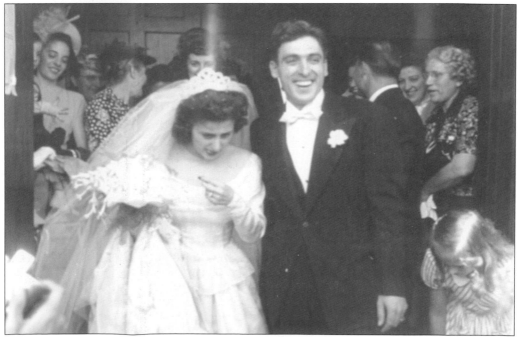

Rose and Frank Adinolfi attended their daughter Gina's marriage to John Francia in 1984, 38 years after their marriage. The proud parents and newlyweds pose in front of the altar in Notre Dame de Chicago Church.

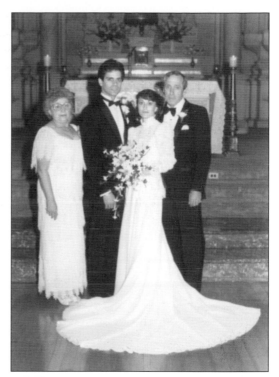

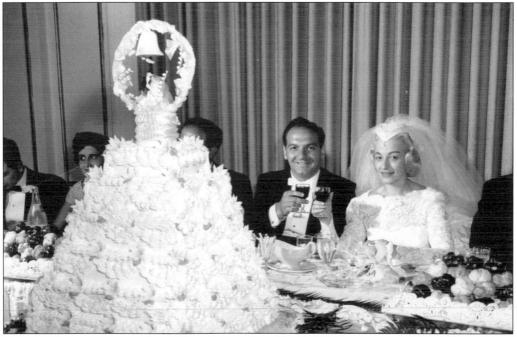

Toasting one another are Donald and Betty Jane (Calabrese) Mentone at their 1959 wedding celebration. The mass was held at Our Lady of Pompeii Church. The cake was the highlight of the catered dinner. Older Italian American weddings often featured boxes of sweets, usually Jordan almonds coated with multicolored hard sugar, or *bomboniera*, to be taken home by the guests after the ceremony.

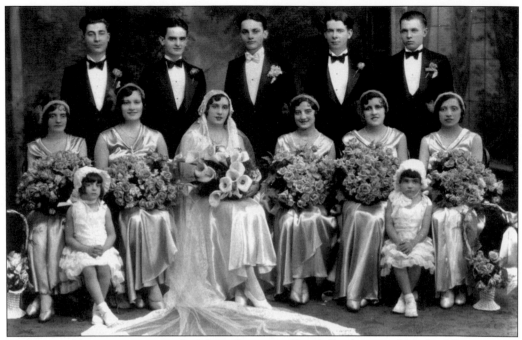

This is a wedding party portrait for Maria Giovanna (Joan) Cerebona and Michael Provenzano, taken on April 12, 1931. They met in the neighborhood when Cerebona was 14. Her father would not allow her to marry until she was 18. Provenzano was 22. Following the ceremony at Our Lady of Pompeii, the reception was held in the ballroom of Hull House. It was a simple menu of Italian beet sandwiches and pastries, drinks, and unshelled peanuts, with the shells landing on the floor—a typical peanut wedding. They were married for 73 years.

Mary (Soldato) Senese poses on February 6, 1927, with her bridal bouquet of lily of the valley, her favorite flower. She and her husband, Vito, were married at Our Lady of Pompeii.

Bride Carmella (Blando) Masi stands between her attendants, Marion Del Guidice (left) and Theresa Abbamonte, after she was married at Our Lady of Pompeii Church in 1943.

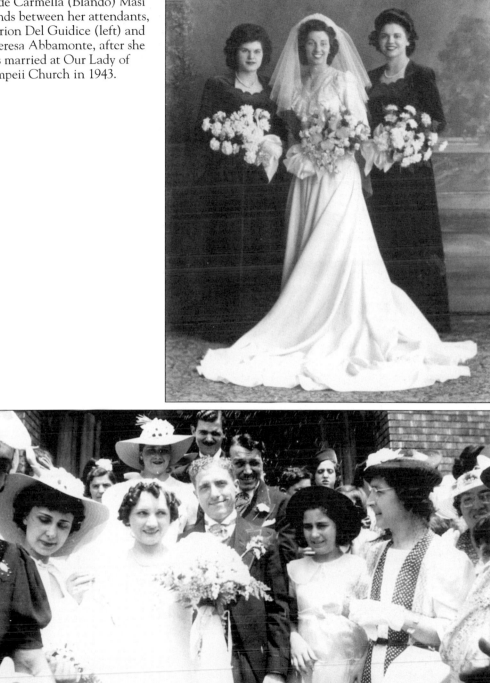

Ann Sorrentino is showered with rice when she and her new husband, Anthony, come out of the church after their June 1939 wedding at Our Lady of Pompeii Church. Anthony was a stalwart and leader in the Italian American community, while Ann was known for her cooking and her recipes that appeared in the *Fra Noi* newspaper for many years, which were compiled into a cookbook after her death. (Courtesy of Dominic Candeloro.)

Lightning struck the wooden statue of Our Lady atop the Notre Dame de Chicago Church on June 7, 1978. Original estimates of more than $1 million led John Cardinal Cody to oppose restoration, but the 250 families in the parish were convinced they could restore it, despite smoke and water damage. For four years, they worshipped in the lower church, while raising the $400,000 for restoration expert William Lavicka. The Reverend Norman Pelletier, pastor, stunned parishioners by holding 1982 Holy Saturday night services in the restored church. The restoration was completed when a new nine-foot-tall statue of the Blessed Virgin and a six-foot, copper-clad pedestal were placed atop the dome. The sculpture, created by Terrill Beatty, was made possible by an anonymous $30,000 donation. The picture below is of the interior on Holy Thursday 1937, the church's golden jubilee year, when 61,000 worshippers came for a special adoration of the Blessed Sacrament. (Courtesy of the Gazette.)

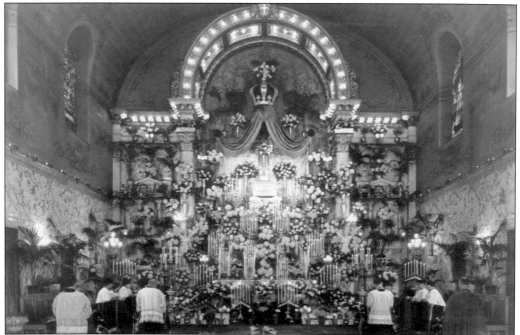

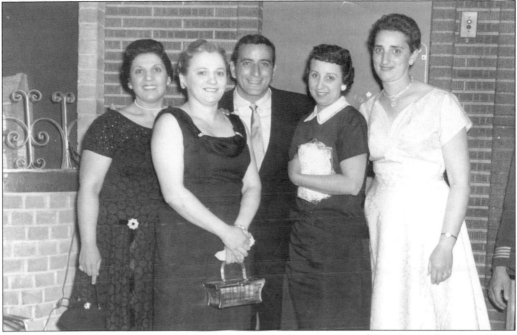

Famous singer, entertainer, and Italian American Antonio Benedetto, better know as Tony Bennett, poses with members of Our Lady of Pompeii bowling team in the 1950s. Seen here are, from left to right, Veronica Pascente, Mary Pascente, Bennett, Rose Guardino, and Ann McAllister. The team went to see Bennett perform downtown.

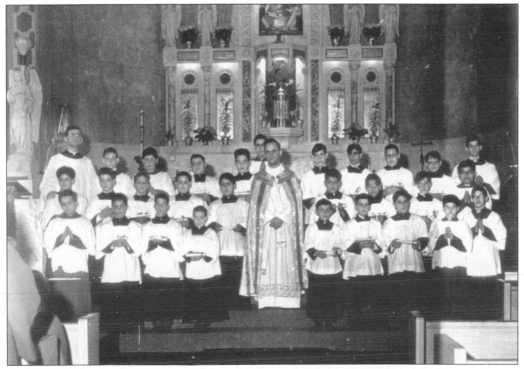

Our Lady of Pompeii's altar boys gather at the front of the church altar.

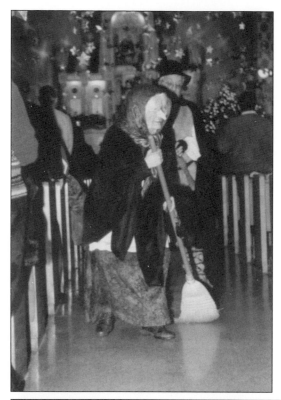

Seen here is La Befana, played by Jean Parisi in January 2004, at Our Lady of Pompeii Church. According to Italian legend, La Befana, too busy cleaning to go with the Three Wise Men, delivers presents of oranges, nuts, and small gifts to all good children on Epiphany. Children who were bad get coal.

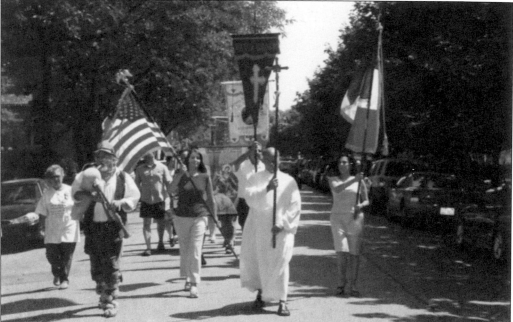

A 2003 procession marches on Lexington Street in celebration of Festa dei Tutti I Santi (Festival of All Saints), held at the Shrine of Our Lady of Pompeii. The man at the left, Lionel Botti, is dressed as a traditional shepherd playing a *zampogna*, an Italian bagpipe. The *festa*, held annually at the end of August, includes a picnic, which draws more attendance every year.

Five

AN HONEST DAY'S WORK
PRIDE IN A JOB WELL DONE

While most immigrants were *contadini* (peasants or farmers) in Italy, in Chicago they became urban workers. Initially Genoese immigrants excelled as saloon keepers, fruit vendors, and confectioners. Others created and sold plaster images or were cabinetmakers. Immigrants were manual laborers, building and maintaining public and private works. Most Italians were on the bottom of the economic ladder until after World War I. Yet the Italian American unemployment rate has consistently been lower than the national average.

Pride in work abounded, and men who earned an honest day's pay happily sent it to Italy for relatives and for women to marry, or started families with local women. The Italian family became an economic entity, with every member expected to help. Older children cooked, cleaned, gardened, and looked after younger siblings with help from aunts, uncles, cousins, and grandmothers.

Before 1900, immigrants found work through the labor agent, or *padrone*, system. In 1916, 50 percent of Italians in Chicago were laborers working construction crews in the mines or railroads. Others were tradesmen, bakers, tailors, or shoemakers, while some opened small businesses or mom-and-pop groceries or were barbers, produce purveyors, or haulers.

A goodly number of Italians went into the manufacturing world growing around them, in the garment, furniture, or printing industries. Italians were among the founders of the Amalgamated Clothing Workers of America. In 1910, a strike against Chicago clothing manufacturers was set off by a "fiery young Sicilian woman," and at least one-quarter of the 40,000 strikers were Italian. To protect themselves and their families, more than 200 Italian mutual benefit associations were formed in Chicago. Italians recognized the value of collective community action to effectively deal with problems of the poor in an urban society.

The transformation from mass migration to contemporary times began in the 1920s. By 1967, Italy ranked first among nations sending immigrants to the United States, professionals and highly trained technicians, especially in the fields of medicine, engineering, and religion. In 2000, 66 percent of Italian Americans were working in white-collar occupations, while 34 percent were blue-collar employees, including farmers, police officers, and firefighters.

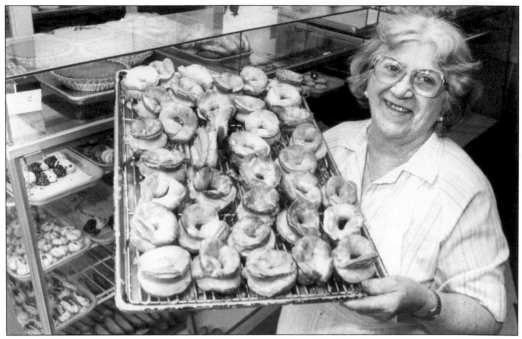

Annette Scafuri Mategrano, in the 1980s, shows off a tray of Italian cookies, carrying on the tradition of her father, who opened his first bakery on Carpenter Street, formerly Shulton Street. The business moved to 818 South Loomis Street and in 1920 to its current 1337 West Taylor Street location. Pompei bakery followed Scafuri at the Loomis Street shop (Courtesy of the Gazette.)

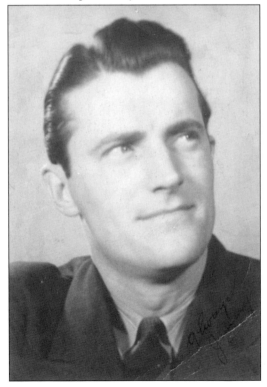

Vincent "Jimmy the Iceman" Masi, seen in this 1936 photograph, worked for his father, Bartolomeo, and uncle Enero Masi in the ice business begun by his grandfather Nick Masi around 1900 at 843 South Miller Street, where the family lived. The business was based in the backyard. Jimmy delivered ice to the neighborhood via horse and wagon until the business closed in 1930.

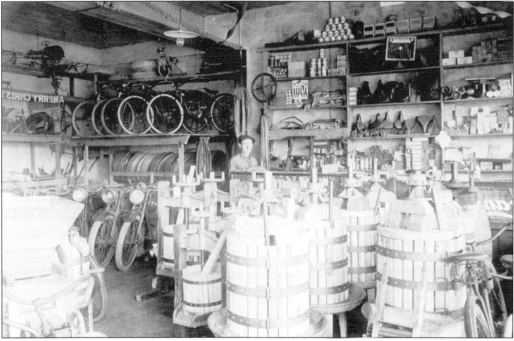

Here are two views of Chiarugi's Hardware Store, a fixture in the Taylor Street area from the 1920s. The local hardware store was and is still known for its wine-making supplies and as a place to purchase nails by the handful or the pound. The image above shows the winepresses in the store. Below, Paul Rinaldi, right, owner in 2006, runs the store his father bought from the Chiarugi brothers in 1960. On the left is employee Edward Getner. (Below, courtesy of Dominic Candeloro.)

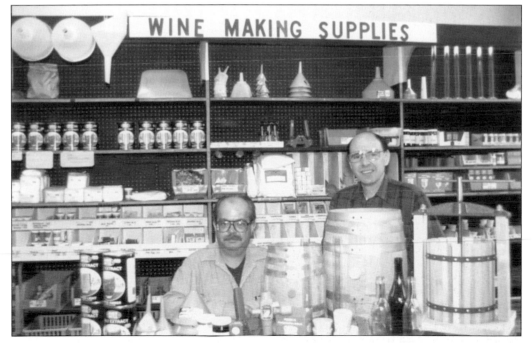

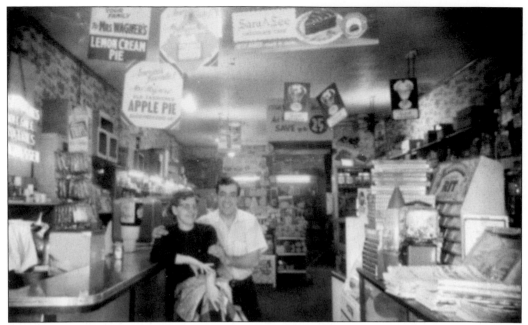

In the image above, Dorothy and Mario DiPaolo pause in Mario's General Store, which was located at 1066 West Taylor Street from 1952 to 1971. The store carried newspapers, cosmetics, cigarettes, food staples, and toys at Christmastime. The DiPaolos also sold sandwiches such as a grilled hot dog on French bread. A favorite was Green River soda. The first store was at Harrison and Leavitt Streets. The image below shows Mario's Lemonade stand, the first incarnation of what has become an iconic institution. Opened in 1962 west of the general store, prices ranged from 40¢ to 10¢ for an Italian ice. An iceman would deliver 100-pound blocks of ice, crucial for Italian lemonade, by horse and buggy through the early 1960s. Mario and Dorothy DiPaolo lean on the counter for this portrait. Their son, Mario Jr., known as "Skippy," runs the operation as of 2006.

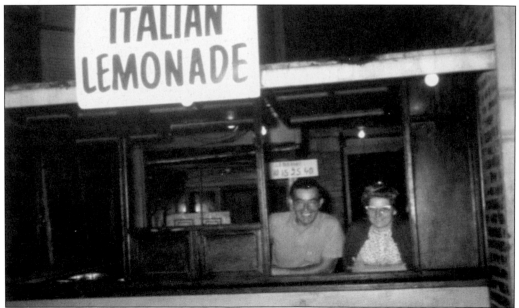

Tom Falbo, of the famous Falbo cheese family, opened his cheese shop in the 1940s at 1335 West Taylor Street. His brother-in-law Joe DeVito, right, made cheeses and Italian sausages and clerked on weekends. Employee Lulu Frulla, left, was beloved by the Falbos and customers. The shop closed in 2000. (Courtesy of the Gazette.)

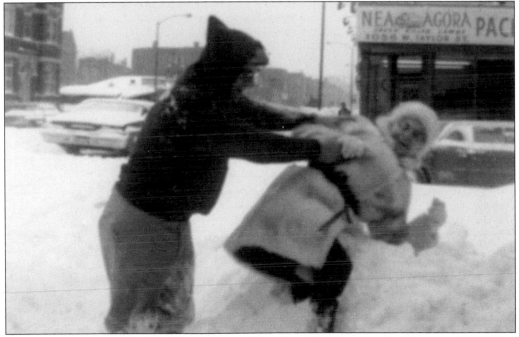

Easter lamb, a holiday favorite, was sought at Nea Agora, seen here in the blizzard of 1967. The butcher shop is still open for business on the corner of Taylor and Carpenter Streets. Today it also services restaurants around the city.

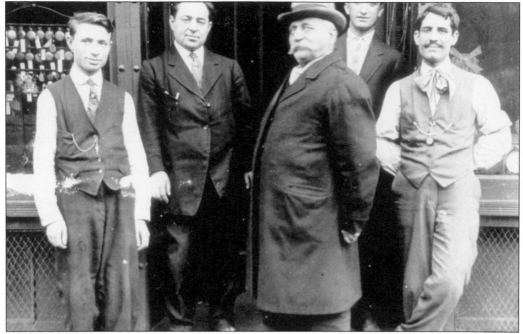

The Mancinelli family is shown near their Taylor Street watch repair and jewelry shop in 1911. Taylor Street was the home of many small shops owned by entrepreneurs who lived nearby. (Courtesy of Dominic Candeloro.)

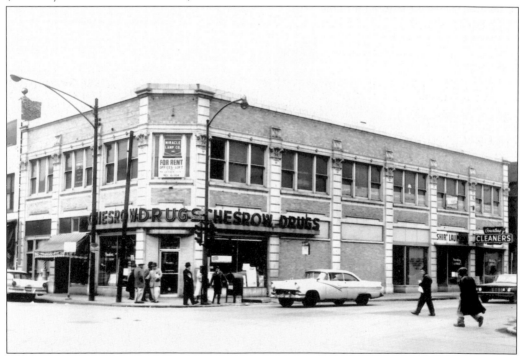

Chesrow Drugs was on the northwest corner of Taylor and Halsted Streets. In the 1950s, it was one of several operated by Frank Chesrow, a pharmacist who also served as a Cook County commissioner. (Courtesy of Dominic Candeloro.)

Seen at right, Pasqualli Monaco opened a drugstore with a relative, Ernesto Monaco, in 1901 at the intersection of Polk and Miller Streets. In the image below, the interior of the P&E Monaco's Pharmacy can be seen. Salvatore Nigro was a clerk in his brother-in-law's store and later became a doctor.

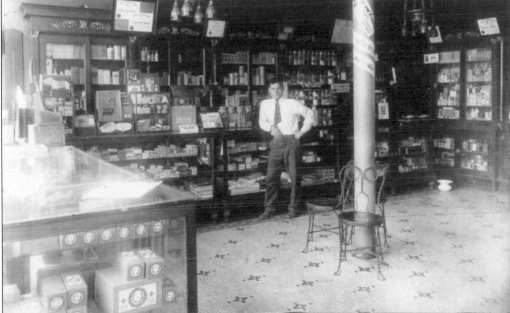

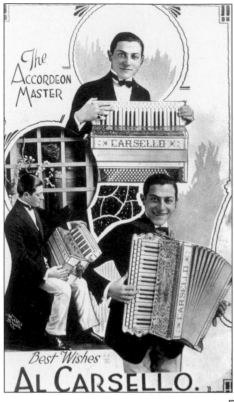

Al Carsello, the "Accordeon Master," in the image to the left, shows off his Carsello instrument in this advertisement for his services. The accordion plays a large role in popular Italian music, as does the mandolin. Seen in the image below, trumpet player Tony Nuzzo was another of the generation of Italian musicians who were known throughout the city. Nuzzo often played for his enthusiastic audiences at the Canton Tea Gardens. Italian musicians and singers became popular beyond Taylor Street from the 1940s on.

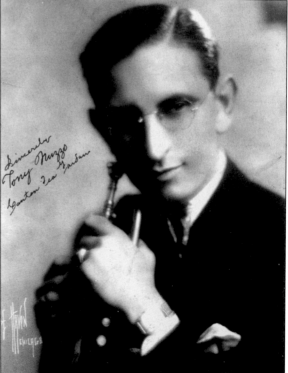

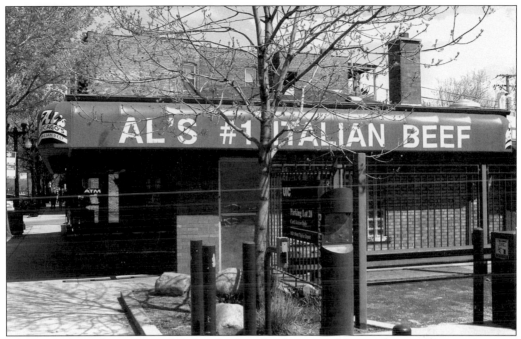

Al's Beef, where the traditional Italian beef sandwich is served hot and wet with your choice of sweet or hot peppers, is a Taylor Street favorite. Town houses replaced Al's Beef in the 1970s urban renewal, so the restaurant moved to Taylor Street, across the street from Mario's Lemonade stand and then expanded into a chain around the city. (Courtesy of the University Village Association.)

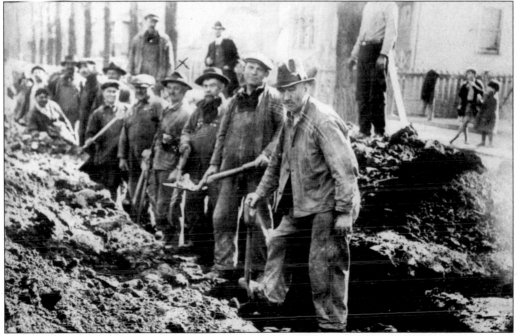

Italian immigrants from the neighborhood provided a willing workforce for major transportation projects such as railroads going west. Here a crew works on Chicago's streetcar system, around the late 1800s.

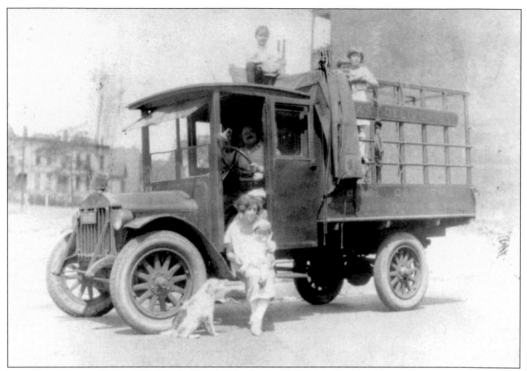

Giuseppe Catrambone is behind the wheel of one of the trucks from his cartage firm, Giuseppe Catrambone and Company. The company evolved into Joseph Catrambone and Sons Cartage when two of the boys playing on the 1928 Diamond T truck grew up and joined the firm. The company specialized in grocery, express, moving, and cold deliveries. The image below shows an invoice used from 1910 to 1919. The firm began at 843 Ewing Street, near Hull House. In addition to the trucking company, Catrambone also had a grocery store on the corner of Polk and DeKalb (now Bowler) Streets and a fish store a couple of doors down. The neighbors sued to close the fish store because of the odor, but Catrambone won the case when the judge said, "Go home and feed your family."

PHONE AUTOMATIC 53995	Chicago,_____191__
M_____	

Bought of Giuseppe Catrambone & Co.

GROCERIES, EXPRESS, MOVING AND COAL DELIVERIES

843 EWING STREET

Lbs.	Chestnut Coal		
Lbs.	Range "		
Lbs.	H. Walley		
Lbs.	Indian Blocks		
Lbs.	Indian Lumber		

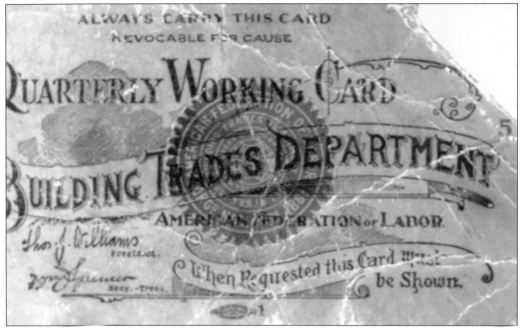

Before he went into business for himself, Catrambone was in the building trades, like many Italian Americans who found jobs in construction. He helped to build the White City amusement park in the city's South Side. His 1915 membership card from the American Federation of Labor Building Trades is seen above.

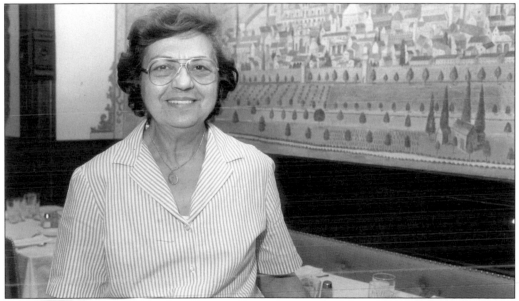

Seen here is Florence Scala at her Florence Restaurant, opened from 1982 to 1989 at 1030 West Taylor Street, where her father, Alessandro (Alex) Giovangelo, had a tailor shop. Scala spent much of her childhood at Hull House, where she performed in plays. She fought city hall as an outspoken critic of the urban destruction resulting in a new campus in the neighborhood for the University of Illinois. Always a political maverick, in 2006 she supported the Green Party gubernatorial candidate. (Courtesy of the Gazette.)

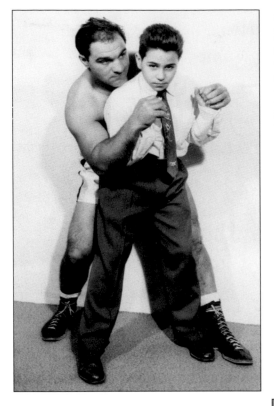

Undefeated heavyweight boxing champion Rocky Marciano came to Taylor Street to talk to boys about the game and how to win. Chuck Giampa, shown here in 1975 as a young man, took Marciano's advice and works as a fight judge in Las Vegas as of 2006. Boxing classes and matches were held at Hull House and Sheridan Park.

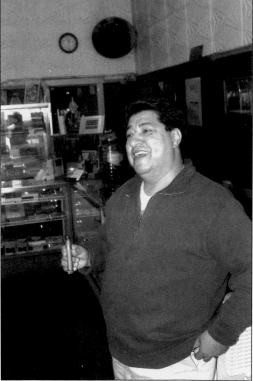

Ralph Rubalcava, of Ralph's Cigars, enjoys a smoke in his shop that arrived on Taylor Street with the popularity of cigar smoking in the 1990s. (Courtesy of the University Village Association.)

Six

THE OTHER
TAYLOR STREET
TRI-TAYLOR

In 1874, in the middle of the Taylor Street area, Cook County located the area's first hospital, responding to lobbying from West Side real estate interests. A number of medical institutions were soon established nearby, such as Rush, St. Luke's, and Presbyterian hospitals and the University of Illinois medical campus. Italian Americans crossed the divide and in essence created two similar but physically unconnected neighborhoods, the west too often lost in the shadow of the eastern, larger, and more populated section of the street. Traditions and family life were identical, as each neighborhood thrived with its own small businesses and strong Catholic parish.

Italian parishes followed the movement of Italian Americans west, or as one commentator put it, "Chicago's Italians overran the Near West Side." George Cardinal Mundelein established St. Callistus Church, at 2167 DeKalb (now Bowler) Street, in 1919 to meet the needs of the increasing population. The first church met in the Baptist church at 2169 DeKalb Street, until the St. Callistus church-school complex was completed in 1926. The Scalabrini Fathers oversaw the church, which had a population of 20,000 by 1937.

The 1941 creation of the Illinois Medical District empowered it to acquire land surrounding the existing medical buildings. The strength of that power was felt in the early 1960s when the eastern part of the neighborhood was leveled, wiping away small businesses and longtime family homes.

The western neighborhood was dubbed Tri-Taylor, inspired by the three Taylor Street intersections: Damen Avenue, Oakley Boulevard, and Western Avenue. It is home to the Chicago Technology Park research center and the West Side Center for Disease Control. The neighborhood includes a national historic landmark district, on Oakley Boulevard from Grenshaw Street to Congress Parkway. Many of the buildings were constructed of Joliet limestone after the Chicago Fire of 1871. Italianate houses, built in the 1870s, can be seen along Bowler Street and Oakley Boulevard and in the 700 and 1000 blocks of Claremont Avenue. These historic homes have undergone extensive renovations, complementing new condominiums and town houses.

The Catrambone Family Memorial Park, at Polk and Bowler Streets, honors the history of Italian family roots in the neighborhood.

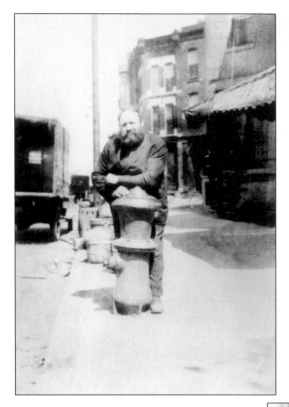

This fire hydrant was extremely large in the early 20th century, as indication of the city's fear of fire. This one was at Polk and DeKalb (now Bowler) Streets, the neighborhood to the west where Italian immigrants and Italian Americans moved following the Great Chicago Fire of 1871.

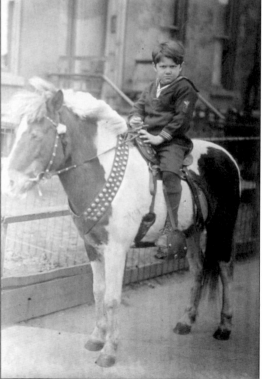

Photography of children on ponies was extremely popular, as the photographer brought his animal around the neighborhood. Joseph B. Catrambone, wearing the ubiquitous boys' sailor suit outfit, looks less than pleased about being seated on top of this horse. The photograph was taken around 1928.

Vito Marzullo was a state representative instrumental in establishing the Illinois Medical District, which would claim part of the neighborhood through eminent domain. He is perhaps better known as "the Dean of the City Council" under Mayor Richard J. Daley. As alderman from 1953 until his 1985 retirement, he ran the 25th Ward virtually unchallenged as one of the last old-time machine politicians.

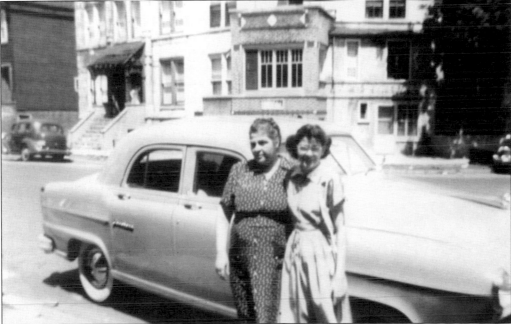

Theresa Catrambone and her daughter Rita are seen here, on the occasion of Rita's 1950 eighth-grade graduation. Rita went on to become a nun in the order of the Sisters of Charity of the Blessed Virgin Mary, who were the teaching nuns at St. Callistus School. The buildings in the back were demolished in the 1960s to make way for the expanding Illinois Medical District.

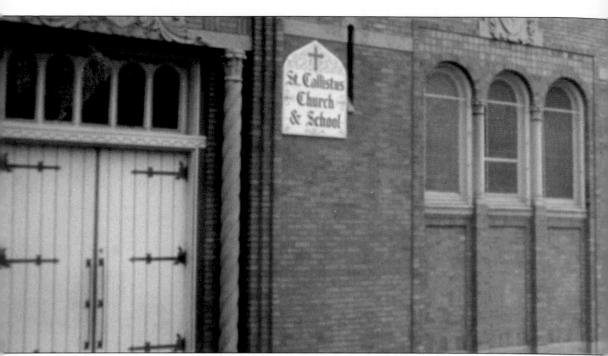

The first mass celebrated in the original church of St. Callistus took place on September 7, 1919. The church officially was dedicated on October 19, 1919. All preaching and announcements were made in Italian. Within six years, a cornerstone was laid for a new church and school building,

Messaggero Celeste, a self-styled messenger of God, celebrated mass, acted as a priest, and conned unsuspecting immigrants. He was put out of business in July 1919, after the Archdiocese of Chicago responded to the request led by James Pacelli for a true Italian Catholic parish. The Reverend William A. Murphy was appointed pastor for St. Callistus. An Irishman, he was versed in Italian and highly regarded as empathetic to Italian Americans. (Courtesy of Dominic Candeloro.)

seen above. The church, left, and original school, middle, were built in 1925, and an addition, right, was constructed in 1955 due to enrollment increases. The "new school," as the addition was called, had a gymnasium, the site of Saturday afternoon movies. Admission was 25¢.

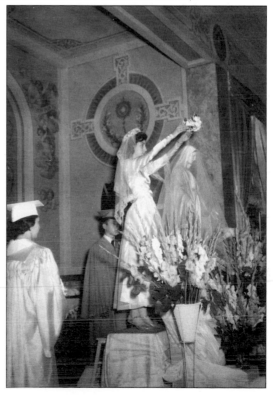

A ceremony honoring the Blessed Mother, called May crowning, was a tradition at St. Callistus. An eighth-grade girl would be chosen to do the honor, as shown in this early-1960s photograph.

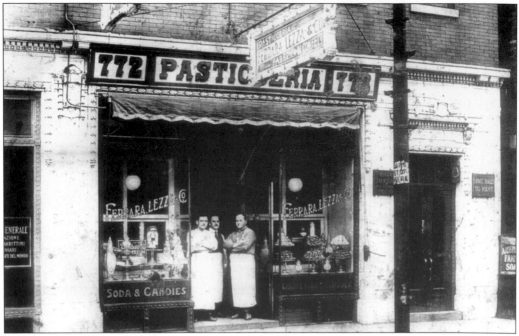

The Ferrara family's first pastry shop and *fabbrica di confetti* opened in 1908 at 772 West Taylor Street. The University of Illinois development forced the shop to move into its candy factory at 2210 West Taylor; the factory moved to larger quarters in suburban Forest Park. The family's third generation operates both businesses in these locations in 2006. Below, Serafina (Pagano) Ferrara, far left, was called the "Angel of Halsted Street" for her quiet philanthropy. The humble Italian immigrant became a civic leader and is pictured here with, from left to right, Eleanor "Sis" Daley, daughter-in-law Marilyn Ferrara, Chicago mayor Richard J. Daley, an unidentified dignitary, and son Nello Ferrara.

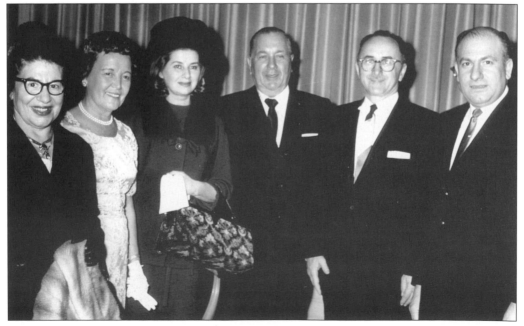

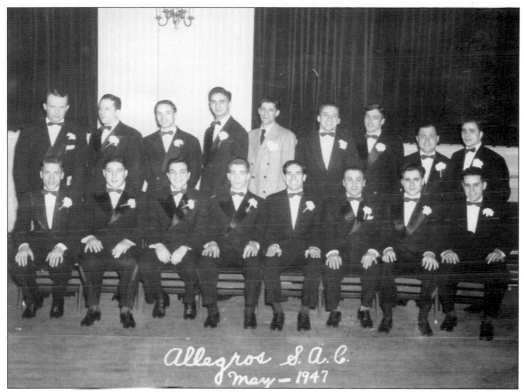

Allegros S. A. C.
May—1947

The Allegros, an Italian American social athletic club, poses at its May 1947 formal dance. In the photograph below, the Rossi baseball team mugs for the camera in 1939. It became the Allegros' team the following year.

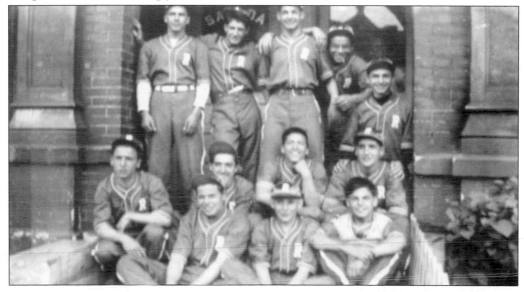

Seen here are historic row houses along DeKalb (later Bowler) Street. Because of their age and nature, they were included in the Tri-Taylor Historic District.

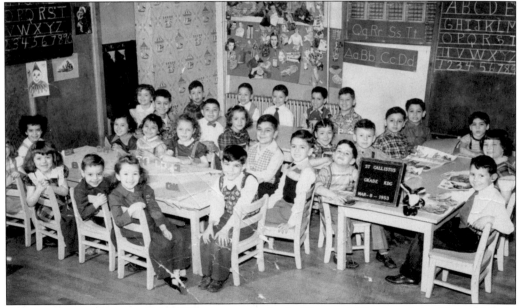

Although most classes at St. Callistus were taught by Sisters of Charity of the Blessed Virgin Mary, St. Callistus graduates of a certain age often fondly recall their lay kindergarten teacher Dorothy Falduto. This is the 1953 kindergarten class photograph.

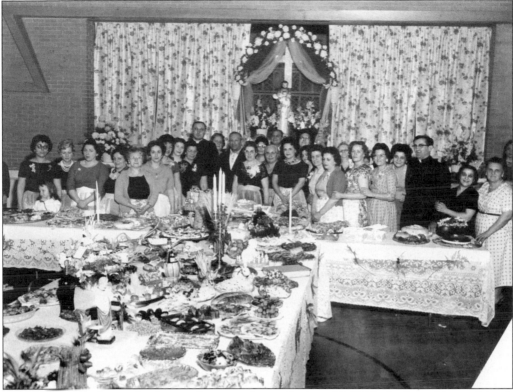

St. Callistus parish was the first in the city to host a St. Joseph's Table for the public, in March 1955. The practice before that had been to hold celebrations for the saint, who is the patron of workers, in private homes. Above is the 1961 Table and the committee that organized the event. A meatless meal, there nevertheless is an array of Italian foods. In the photograph below are the first officers of the Fathers Club, which organized the St. Joseph festivities.

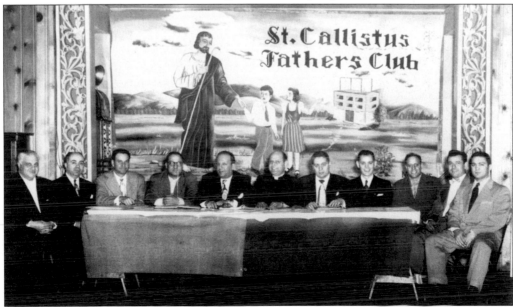

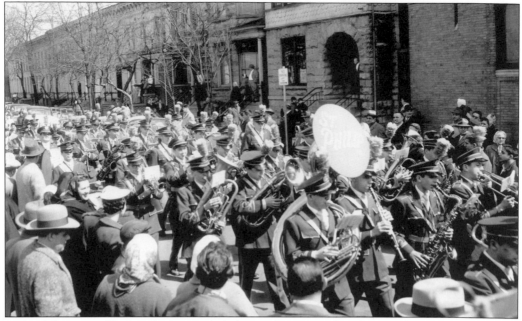

Early celebrations of St. Joseph's Day included a parade on Saturday afternoon before the St. Joseph's Table opened the next day. The parade featured high school marching bands such as this one from St. Philip High School, above, and students on floats, below. Schoolchildren, including Boy and Girl Scouts, also marched through the streets of the St. Callistus neighborhood, passing landmarks such as the Cozzi Butcher Shop, Traficante Brothers Drugs, Vesuvio Bakery, and Albano Pasty Shop. Earlier that day, the men and boys of the parish attended a special mass.

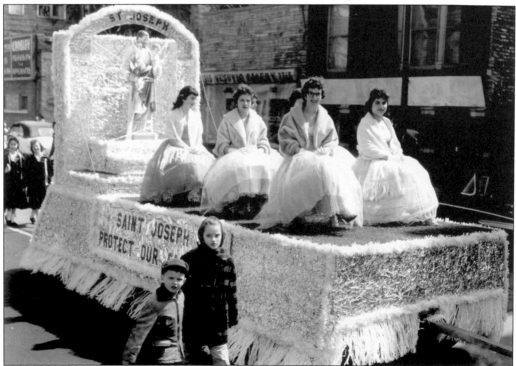

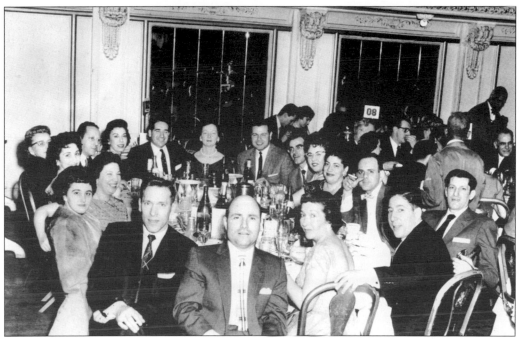

Men and women from St. Callistus Church join the St. Joseph's Day festivities at a 1950s dinner dance held on Saturday night preceding the Table mass. The dinners were often held at the Sherman House in downtown Chicago and featured named entertainment such as Jimmy Durante, Sammy Davis Jr., and Steve and Eydie Gorme.

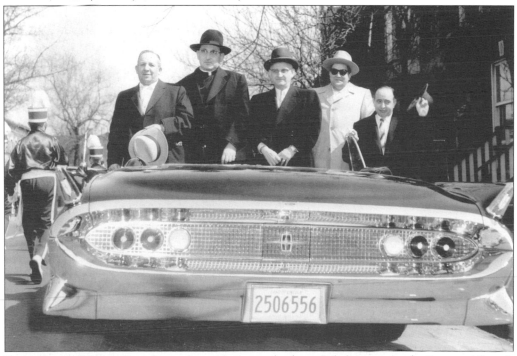

Reviewing the 1956 St. Joseph parade are chairman Anthony Policheri; pastor, the Reverend Peter J. Sordi, C.S.; alderman Vito Marzullo; John Landato; and state representative Sam Romano.

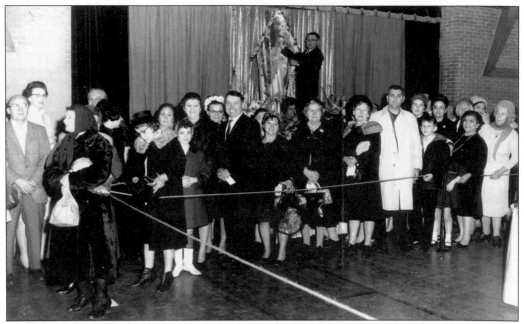

The Italian tradition of pinning donations (man standing in the background) to the statue of St. Joseph continued through to the 50th—and last—St. Joseph's Table of St. Callistus Church. The Table event was created to help feed the poor and was modeled after old-country Italian traditions. In the foreground, patrons wait to be served.

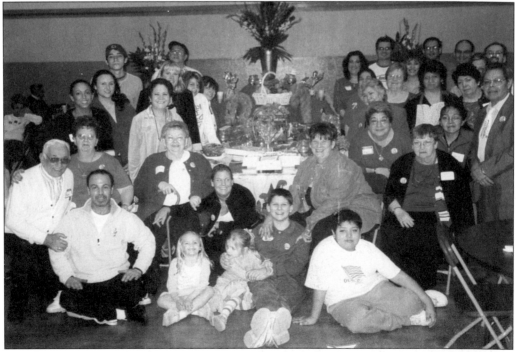

A month before the last St. Joseph's Table was to be held, St. Callistus School was abruptly closed for safety reasons. The event was moved to Holy Trinity School on Taylor Street. The committee for the last St. Joseph's Table at St. Callistus Church pose for this picture in 2004.

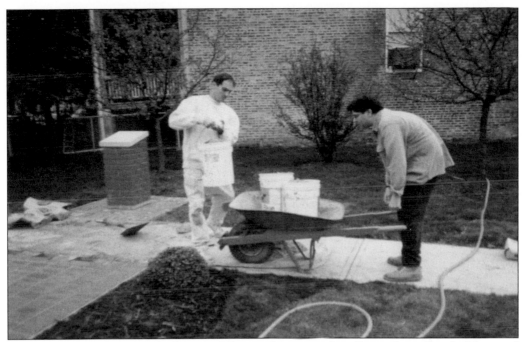

Two Catrambone cousins, both named Joe, work to complete Catrambone Family Memorial Park before its May 1997 dedication. The park was a joint project of the Illinois Medical District and the Catrambone family. The park is on the site of a former Sinclair gas station that had been in operation for at least 40 years since the 1920s at the corner of Polk and DeKalb (now Bowler) Streets.

Vito Catrambone, one of the patriarchs of the family, unveils the monument at a ceremony attended by many relatives, friends, and then Illinois attorney general Jim Ryan, whose Italian mother grew up down the street from the park site.

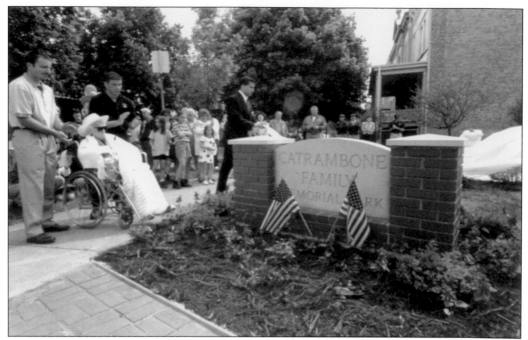

Jennie Catrambone, one of the family matriarchs, admires the park, which was dedicated to the relatives who came to America to seek a better life and "to all immigrants who call the neighborhood home."

Albert Catrambone lays a brick inscribed with the names of his parents while his sister Arlene Gaudio captures the moment on film. The park was financed through the purchase of inscribed bricks.

Seven

Double-Edged Sword
Urban Renewal

The physical division of the Taylor Street-Little Italy community began with the 1941 establishment of the Illinois Medical District. The destruction of the neighborhood came with Congress (Eisenhower) Expressway in the 1950s, followed by the 1960s construction of the University of Illinois's Circle Campus (today's UIC). "The neighborhood around Pompeii Parish was decimated and tortured by twin monsters: Urban Renewal and the establishment of the University of Illinois at Chicago campus," wrote anguished pastor of Our Lady of Pompeii the Reverend Gino M. Dalpiaz, C.S., in 1974.

Creating a state university in Chicago was the dream of many, dating back to 1946. The site choice, finally made in the early 1960s, was the Near West Side rather than the suburbs. Overriding the intent of the Near West Side Planning Board that in 1959 had begun residential development on a 55-acre Harrison-Halsted area, the city saw that location as an anchor for Near West Side redevelopment east of the Illinois Medical Center, good for the university and providing federal subsidy opportunities. In February 1961, the city's offer of the land was accepted by the university. A gargantuan battle ensued between Mayor Richard J. Daley aligned with University president David Dodds Henry against the neighborhood and its residents. Angry neighbors, led by Florence Scala, organized and held mass protests, including sit-ins in Mayor Daley's office, but were unsuccessful, even in court.

Between the 1950s and 1960s, two-thirds of the housing in the Our Lady of Pompeii parish was razed for the university and highway. The campus alone displaced 1,900 families, 630 businesses, and a never-replaced Holy Guardian Angel Church and School. Still, as Father Dalpiaz wrote, the neighborhood "refused to die." Rejuvenation came with the rehabilitation of old homes and the construction of many new town houses, maintaining a strong ethnic community. Two decades later, in 1978, 50 percent of the 660 families in the Our Lady of Pompeii parish still were of Italian descent.

The events also created a diaspora of Italian Americans to other locations in the city and suburbs. Many still thought of Taylor Street as home or at least the neighborhood of their roots.

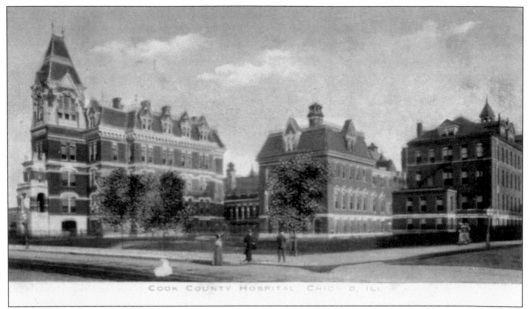

The Illinois Medical District had its start in the 1870s when the first public hospital, Rush Medical College, and the College of Physicians and Surgeons were established following the Chicago Fire of 1871. The medical district is, as of 2006, one of the largest urban health-care, educational, research, and technology districts in the nation. From its inception, the Illinois Medical District has continued to grow. The first Cook County Hospital was razed and replaced by the "new" Cook County Hospital, at 1900 West Harrison Street. The former (seen above) was razed, while the latter (below) has been replaced with John H. Stroger, Jr. Hospital of Cook County. In 2006, many seek to demolish this building while strong preservationist voices argue for retaining and restoring it to an alternative use. No decision had been made as of 2006.

Rush Medical College, at Wood and Harrison Streets, has been part of the Chicago landscape longer than any other health-care institution in the city. It received its charter on March 2, 1837, two days before the City of Chicago was incorporated. Founder Dr. Daniel Brainard named the school in honor of Dr. Benjamin Rush, the only physician with medical school training to sign the Declaration of Independence. This building was erected in 1877 next door to the county's hospital. This picture postcard was sent by Sister Anna to fellow nun Sister Marie Skoien in Fergus Falls, Minnesota. Written in Swedish, the card speaks of goings-on at the hospital, which was linked with St. Luke's and Presbyterian Hospitals in 1956.

In 1969, Rush Medical College reactivated its charter and merged with Presbyterian-St. Luke's Hospital, which itself had been formed through merger in 1956, to form Rush-Presbyterian-St. Luke's Medical Center. Presbyterian Hospital had been built in 1883. Rush University, which now includes colleges of medicine, nursing, health sciences, and research training, was established in 1972. The medical complex officially changed its name in September 2003 to Rush University Medical Center to reflect the important role that education and research play in its patient care mission.

Rush-Presbyterian-St. Luke's Medical Center rises above the Eisenhower Expressway, symbolizing the growth of both the medical center district and the highway expansion that cut through the Taylor Street neighborhood. (Courtesy of the Near West Side Slide Archive.)

Seen here is the building of the new hostelry near the medical campuses that services visitors to the hospital complex and parents of university students. In 2006, the hotel is being run by the Marriott Corporation. (Courtesy of the Near West Side Slide Archive.)

Much of the urban development that went on in the area between the two ends of Taylor Street was involved in creating a new UIC campus. Begun in the 1960s and continuing to grow through the start of the 21st century, UIC has morphed from a strictly commuter school to a public, state-supported research university with the largest university population in the Chicago area, boasting 25,000 students, 15 colleges, and the nation's largest medical school. Close to public transit and the Loop, UIC has answered the dream of Mayor Richard J. Daley and brought a new student population to frequent Taylor Street. In the image to the right, the university is seen in the sunset overlooking the city of Chicago. In the image below, the construction can be seen, with chaos and building around the main building of Jane Addams' Hull House, which is now a museum on the campus. (Courtesy of Near West Side Slide Archive.)

This is a view of Halsted Street looking south at Polk Street as UIC was being constructed, in November 1964. (Courtesy of the Near West Side Slide Archive.)

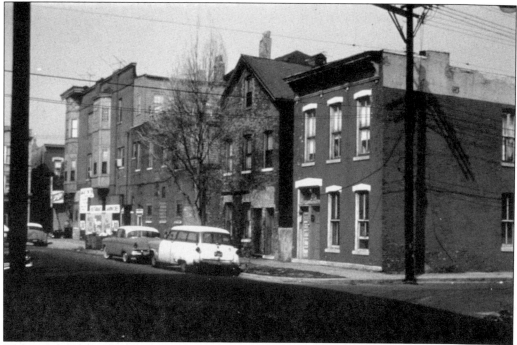

This is the north side of Vernon Park Place looking toward Racine Avenue that was demolished and replaced by university building in the neighborhood. (Courtesy of the Near West Side Slide Archive.)

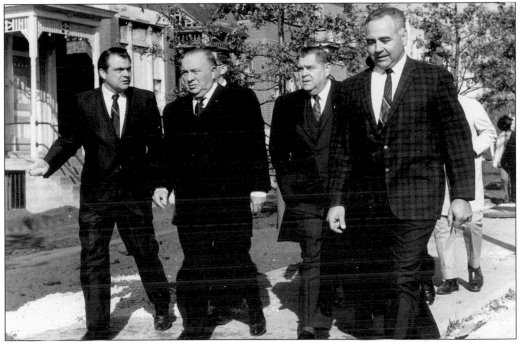

Chicago mayor Richard J. Daley, second from left, walks the neighborhood in October 1968 to view new construction with his director of the Department of Urban Renewal, Christopher Hill, left, and two unidentified officials.

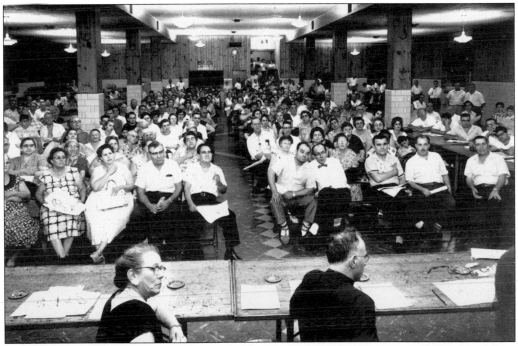

A meeting on the Near West Side was held to protest the construction of UIC. Neighbors held meetings and sit-ins and created media publicity. It was to no avail, however. (Courtesy of Dominic Candeloro.)

In the image to the left, Christopher Columbus stands tall in Arrigo Park, named for Victor Arrigo (1908–1973), an advocate for the Italian American community who served as Illinois state representative for Chicago's near southwest side from 1966 to 1973. The statue is being moved into the park in the image below. Arrigo was instrumental in bringing sculptor Moses Ezekiel's statue to the park in 1966. First exhibited in the Italian pavilion at the 1893 World's Columbian Exposition, the bronze figure later graced a second-story alcove on State Street's Columbus Memorial building. After that building was razed in 1959, the statue went into storage. (Courtesy of the Near West Side Slide Archive.)

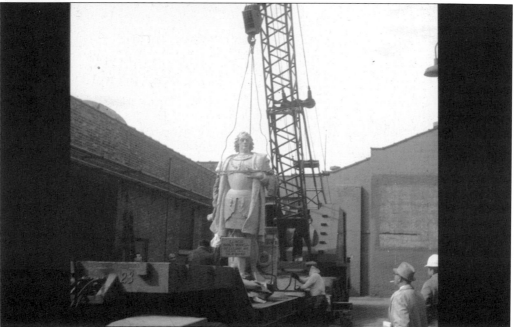

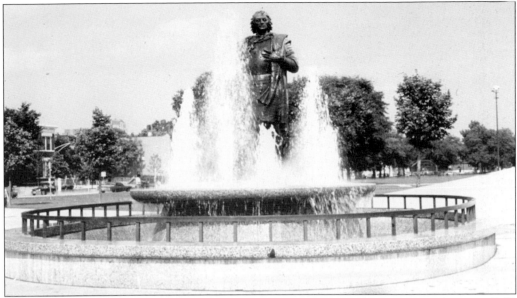

The Columbus statue ended at its final resting place, a fountain facing Loomis Street at Polk Street. Italian Americans look upon Columbus as a symbol of their exploratory nature. (Courtesy of the Near West Side Slide Archive.)

The first Columbus Day parade was held in 1868 by the earliest immigrants. The Joint Civic Committee of Italian Americans today sponsors the citywide parade and has since 1952. The parade is an opportunity for Italian Americans to express pride in their heritage and culture. A wreath is laid at the statue each Columbus Day following a mass at Our Lady of Pompeii attended by city dignitaries. In the photograph above are Natalie Barselle, center, the 2003 queen; Caterina Alberotanza, as Queen Isabella; John Galluzzi, as Christopher Columbus; and the queen's court, from left to right, Maria Angela Rito, Amanda Giovanni, Stephanie Minkely, and Lauren Tortorice.

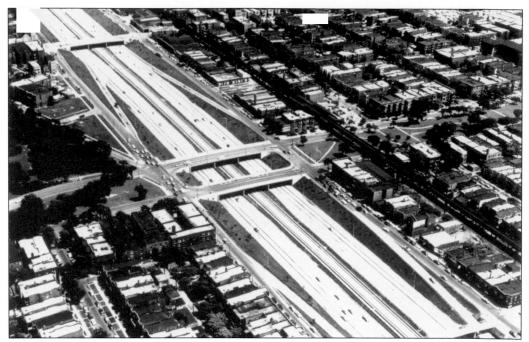

The Congress (later Eisenhower/Interstate 290) Expressway, completed in 1956, sliced the neighborhood apart. The highway widened what had been a traditional city street. Chicago, unlike many American communities, names its expressways beyond identifying them by number. The Congress Expressway was named for the president who spearheaded the construction of interstate highways across the country, Dwight David Eisenhower. (Courtesy of the Chicago Historical Society.)

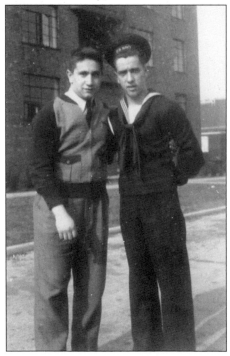

World War II's returning soldiers and sailors, such as these, were the focus of the Jane Addams Homes, or what were later to be known as the projects. One aim after the war broke out was to provide inexpensive and clean housing for those who had served their country, giving them a leg up on reentering civilian society.

Built in 1938, the ABLA Homes (Jane Addams Homes, Robert H. Brooks Homes and the Brooks Extension, Loomis Courts, and the Grace Abbott Apartments) after nearly 60 years were declared obsolete by the Chicago Housing Authority. They have been razed and are being replaced by mixed-income, mixed-use development, much of it under the name of Roosevelt Square. (Courtesy of the Gazette.)

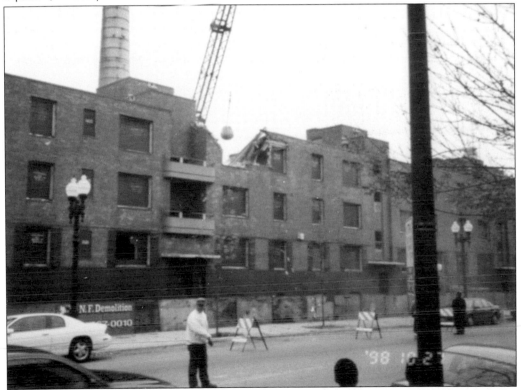

This image shows the demolition of the Jane Addams Homes, which began in the late 1990s and was still going on when this picture was taken in October 1998. Demolition continued into 2006. (Courtesy of the Gazette.)

Seen here is the demolition of a liquor store along Taylor Street in order to construct the National Italian American Sports Hall of Fame (see chapter 8). Because of the wares it sold, the shop had poor relations with its neighbors. (Courtesy of the Gazette.)

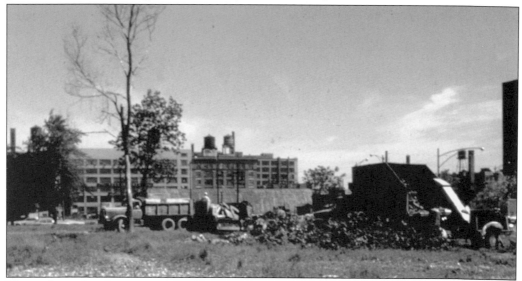

This is the sight of construction equipment that was ubiquitous throughout the neighborhood during the past four decades, the 1960s through 2006. Above, a townhome development, Westgate Terrace, on the former site of the Little Sisters of the Poor building. Westgate Terrace was the first new townhome project, spurring the revival of Taylor Street area in 1966. An amazing 12 bids for the project were received. One was disqualified because it arrived after a 2:00 p.m. deadline. The bidder had forgotten that there was a taxi strike and delivered the bid on foot—late. (Courtesy of the Near West Side Slide Archive.)

Eight

SURVIVING, THRIVING
BENVENUTO, AGAIN, TO LITTLE ITALY

Chicago is third among American cities with the most Italian American residents, behind only New York and Philadelphia (according to the 2000 United States Census). Pride in Italian tradition and heritage continues along Taylor Street, Little Italy, which was the soil that nurtured Italian roots.

Land values have risen, occupations and incomes have changed, and development continues. The Near West Side, with rebuilt sections such as University Village, has become increasingly attractive to middle- and upper-middle-class Chicagoans and returning suburbanites, particularly those interested in living near downtown. Taylor Street today pops its buttons with an enhanced streetscape and activity from restaurants, shops, and the local Chicago Public Library branch. The old public housing project buildings are gone, and in their place are new housing units, either rental or condominium apartments and town houses, standing cheek by jowl with restored historic buildings.

Drawing visitors is the National Italian American Sports Hall of Fame, designed by well-known local architect John Vinci. The 35,000-square-foot museum includes the Tommy and Jo Lasorda Exhibit Gallery and the 225-seat Frank Sinatra Performing Arts Center. Founder George Randazzo officially opened the first hall of fame in Elmwood Park in 1978, but the museum was eventually moved to 1431 West Taylor Street. Across the street is the *piazza* (park) with a bronze statue of New York Yankees baseball legend Joe DiMaggio, who in 1999 came to Taylor Street to break ground for the hall of fame.

On October 10, 1994, Joseph Cardinal Bernardin proclaimed Our Lady of Pompeii Church a shrine: a center of hospitality, evangelization, and spiritual growth. Incorporating the Italian language into parts of the mass, Our Lady of Pompeii carries on old traditions.

Beyond the borders of Taylor Street, but reflected in the street's rebirth, is the adoption of Italian culture as part of America. Spaghetti and lasagna, Joe DiMaggio and Frank Sinatra today are as American as they are Italian, like the residents and ancestors of Taylor Street. What is left and what has been rebuilt on Taylor Street remains the heart and soul for many Chicago Italians.

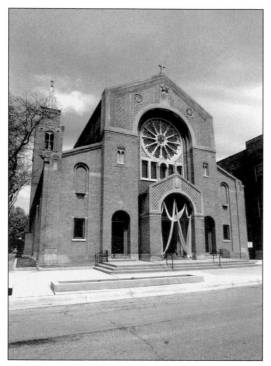

The church of Our Lady of Pompeii, the oldest Italian American church in continuous use in Chicago, was declared a shrine by Joseph Cardinal Bernardin, thus breathing new life into the venerable institution. (Courtesy of the University Village Association.)

The city of Chicago is a fitting backdrop to Taylor Street of the 21st century. The neighborhood's adjacency to the Loop has played a strong role in its history. While 19th-century immigrants moved close to the train stations where they arrived, 21st-century residents look to be near their jobs in the Loop. (Courtesy of the Near West Side Slide Archive.)

The last of the Jane Addams Homes, part of the ABLA Homes that sat along Taylor Street since the 1930s, are empty as of 2006 and being readied for new development by the Chicago Housing Authority and private developers.

Francesca's on Taylor, at the corner of Taylor and Loomis Streets, features the cuisine of Rome, Tuscany, Umbria, and Lazio. This popular restaurant has borne a chain of Francesca's throughout the city and suburbs.

Rosebud, located at 1500 West Taylor Street, originally opened in 1977. A magnet for celebrities and tourists, it is known for its chicken vesuvio and other pasta dishes, which are served in mammoth portions. Like many of its fellow Taylor Street eateries, Rosebud also has a chain throughout the city and suburbs.

Pompei, now at the end of Taylor Street where it meets Ashland Avenue at 1531 West Taylor Street, has been on the neighborhood scene since 1909, moving from smaller quarters to this beautiful building with outdoor seating. Specializing in homemade pizza, the restaurant is open for both lunch and dinner. Its owners, the Davino family, opened outlets in the city and suburbs.

Tuscany restaurant, located at 1014 West Taylor Street, boasts a light decor to welcome those favoring northern Italian specialties. It has been on the street since 1990, just where Taylor Street begins, west of the UIC campus. It is on the site of a family-owned grocery store, West Side Foods, operated by Salvatore (Sam) Senato around 1940 to 1965.

Mario's Italian Lemonade, of 1068 West Taylor Street, is a neighborhood and city institution and epitomizes both the history and flavors of Little Italy. Lines of customers flow into the street, particularly on hot summer nights. It is open May through September for the taste of the old neighborhood.

Salvatore and Roseanne Perry both grew up in the neighborhood before they married. He worked in his parents' bakery and had his own grocery store at the age of 17. She was an excellent cook. They opened RoSal's Italian Cucina in 1990 and serve family Sicilian recipes, some of which are more than 100 years old. The restaurant is at 1154 West Taylor Street.

Leona's restaurant is yet another Italian favorite that has locations around the city, including one on Taylor Street.

Two young men enjoy evening al fresco dining at Hawkeye's, on Taylor Street, at the corner of Laflin Street since 1987. (Courtesy of the Near West Side Slide Archive.)

In the rejuvenation of the neighborhood, many young professionals and young people with children have moved into the neighborhood, some of them returning to the area where they themselves grew up. (Courtesy of the Near West Side Slide Archive.)

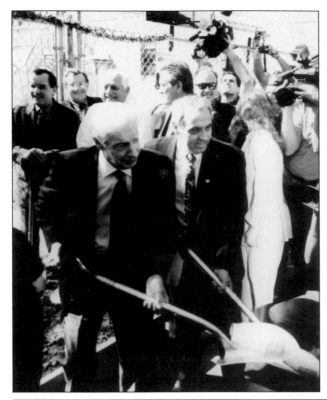

Famous baseball player Joe DiMaggio (left foreground) came to Chicago in 1999 to break ground for the National Italian American Sports Hall of Fame. Behind him are, from the left to right, Mayor Richard M. Daley and Tommy Lasorda, for whom an exhibition hall is named inside the hall. (Courtesy of the National Italian American Sports Hall of Fame.)

The statue of Joe DiMaggio, the Yankee Clipper, is forever hitting a home run out of the park that is named for him, across the street from the National Italian American Sports Hall of Fame. (Courtesy of the Near West Side Slide Archive.)

118

Piazza DiMaggio, in which the statue is central, faces Taylor Street, across from the National Italian American Sports Hall of Fame. (Courtesy of the Near West Side Slide Archive.)

The National Italian American Sports Hall of Fame, 1431 West Taylor Street, touts the accomplishments of athletes such as Mario Andretti, Ron Santo, and Vincent Lombardi, from auto racing, baseball, and football, respectively.

The historic graystones in the Taylor Street Little Italy neighborhood are no longer split into small units and teeming with people. Today's graystones are appreciated for the beauty of their Richardsonian Romanesque style and history. (Courtesy of the Near West Side Slide Archive.)

Seen here is the active night scene, facing east, along Taylor Street. (Courtesy of the Near West Side Slide Archive.)

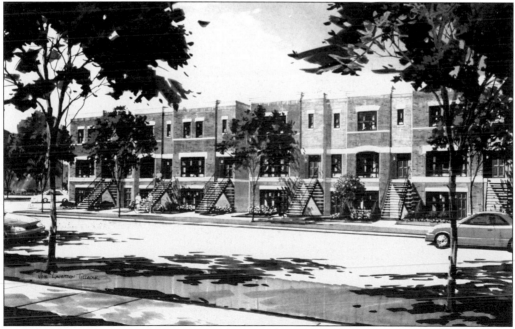

Vernon Square New West Associates development (in rendering) that went up on the 1300 block of Fillmore Street is typical of the new development. Pictured are buildings constructed on the north side of Fillmore. (Courtesy of the University Village Association.)

The former Cabrini Hospital, 811 South Lytle Street, has become Columbus on the Park, a development of the Kenard Corporation. The hospital was converted into 105 lofts. Twenty-eight town houses were built on what had been the hospital's parking lot.

Lifelong neighborhood resident Mary Pascente was awarded the Humanitarian of the Year Award in 1988 by the Near West Side Council, whose mission is to aid the development of Taylor Street. She was honored for her work as one of the Chicago Police Department's first community beat coordinators. (Courtesy of the Gazette.)

The clock in front of the ABC Bank along Taylor Street shows a Beaux-Arts style and is indicative of the changes that have come about as the street grew from one housing mom-and-pop stores to service the residents of tenements to one of sophisticated restaurants serving middle- and upper-middle-class neighborhood residents. (Courtesy of the University Village Association.)

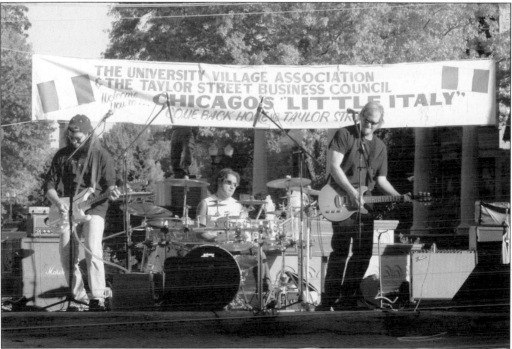

The University Village Association's purpose is to promote the neighborhood, as it does with periodic events. (Courtesy of the University Village Association)

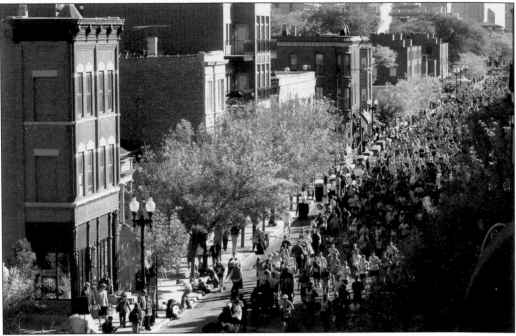

The LaSalle Bank annual marathon makes its way through Little Italy, along Taylor Street, each year. As the years have gone by, more and more people line the streets to cheer on the runners. (Courtesy of the Near West Side Slide Archive.)

A playground, named for John McClaren (1836–1916), a Chicago businessman, was located here near McClaren School in 1901. In 1979, the park was renamed for Giuseppe Garibaldi (1807–1882), the Italian general who conquered the Kingdom of the Two Sicilies in 1860. The Garibaldi statue, which had been in Lincoln Park since 1901, was moved to this park in 1982. (Courtesy of the Near West Side Slide Archive.)

The *Fra Noi*, the English-language Italian-news newspaper, has been covering the Italian American community throughout Chicago and suburbs since 1960.

This is 1246 West Lexington Street, which the UIC president bought and lived in. Symbolic for the residents of the community who had vigorously opposed the UIC campus construction, the house is a link between the university and the neighborhood. It also is an excellent example of the historic homes that have been restored and stand alongside new development. (Courtesy of the Near West Side Slide Archive.)

Taylor Street still conjures up thoughts about the heritage and achievement of Chicago's Italian people. "Our parents came here with pride, respect, morals and loyalty to America . . . Our community has come a long way and we've earned every inch of our progress . . . by sweat, love and respect. We are a loving and proud nationality," wrote Michael Provenzano of Niles in February 1998. Few can say it better than a man whose roots were on Taylor Street.

BIBLIOGRAPHY

Candeloro, Dominic. *Italians in Chicago*. Charleston, SC: Arcadia Publishing, 1999.

———. "Chicago's Italians: Immigrants, Ethnics, Achievers, 1850–1985," Parts 1 and 2. www.virtualitalia.com.

Dalpiaz, Fr. Gino M., C.S. "Memorandum on the History, Present State, and Prospects of Our Lady of Pompeii Parish." Archdiocese of Chicago archives.

Department of Urban Renewal, City of Chicago, Richard J. Daley, Mayor, John G. Duba, Chairman, James D. Green, Peter M. Kelliher, Robert N. Landrum, and Remick McDowell. "A History of Saint Frances Xavier Cabrini Hospital." Archdiocese of Chicago archives, November 1962.

DiBenedetto, Alessandra. "Italian Immigration to the University States." Tampere, Finland: FAST-Area Studies Program, Department of Translation Studies, University of Tampere. www.uta.fi/FAST/US2/PAPS/db-italy.html.

Grossman, James R., Ann Durkin Keating, and Janice L. Reiff, eds. *The Encyclopedia of Chicago*. Chicago: University of Chicago Press, 2004.

Italian-American Collection. Special Collections Division of the University (Richard J. Daley) Library at the University of Illinois Chicago.

Italian-American Women's Club. *Italian-American Women of Chicagoland*. Charleston, SC: Arcadia Publishing, 2003.

Iorizzo, Luciano J., and Salvatore Mondello. *The Italian Americans*. The Immigrant Heritage of American Series, edited by Cecyle J. Neidle. New York: Twayne Publishers Inc., 1971.

Lindberg, Richard. *Passport's Guide to Ethnic Chicago, A Complete Guide to the Many Faces & Culture of Chicago*. Lincolnwood: NTC Publishing Group, 1993.

Micheletti, Antonio, La Vita Italiana, Inc., "Chicago's Little Italy: A Community Lingering to Last." www.littleitalychicago.com/history/littleitaly.shtml.

National Endowment for the Humanities. *Italians in Chicago, The Italian in Chicago Project*.

Nelli, Humbert S. *Italians in Chicago 1880–1930: A Study in Ethnic Mobility*. New York: Oxford University Press, 1979.

Rosen, George. "The Siting of the University of Illinois at Chicago Circle: A Struggle of the 1950s and 1960s." From *Chicago History*, Winter 1980–81. Chicago: Chicago Historical Society.

Shaw, Stephen Joseph. *The Catholic Parish as a Way-Station: Chicago Studies in the History of American Religion*. Brooklyn: Carlson Publishing, 1991.

ACROSS AMERICA, PEOPLE ARE DISCOVERING SOMETHING WONDERFUL. *THEIR HERITAGE.*

Arcadia Publishing is the leading local history publisher in the United States. With more than 3,000 titles in print and hundreds of new titles released every year, Arcadia has extensive specialized experience chronicling the history of communities and celebrating America's hidden stories, bringing to life the people, places, and events from the past. To discover the history of other communities across the nation, please visit:

www.arcadiapublishing.com

Customized search tools allow you to find regional history books about the town where you grew up, the cities where your friends and family live, the town where your parents met, or even that retirement spot you've been dreaming about.